PLACES Aaron Siskind Photographs

PLACES

Aaron Siskind Photographs

INTRODUCTION BY THOMAS B. HESS

LIGHT Gallery New York

Farrar, Straus and Giroux New York

7500 copies of this book

designed by Malcolm Grear Designers

type set by Dumar Typesetting, Inc.

printed by Pentacle Press

on Warren Cameo Dull

ISBN: 0-374-23205-9

Library of Congress Card Catalogue no. 76-42067

Introduction THOMAS B. HESS

And now I study the diary

of a slate summer's scratches,

the language of flint and air,

a stratum of darkness, a stratum of light . . .

Mandelstam (*A Slate Ode*),
translated by Burton Raffel and Alla Burago

(fig. 1) Not at Home EASTMAN JOHNSON Courtesy Brooklyn Museum

The "dirty little secret."

For D. H. Lawrence, who coined the epithet, the "secret" was sex in British society in the first decades of the twentieth century.

In the fine arts, that is to say among painters, sculptors, plus a few printmakers, it's been photography—the mixture of photography with art, the claims of photography to art. And it only recently has come out of the darkroom. It only recently has become common knowledge that artists began to incorporate photography into painting and drawing shortly after Daguerre's discovery in 1837, in spite of denunciations by aestheticians and poets, who excluded the camera from Parnassus. Baudelaire fulminated; in his *Salon of 1859* he blamed photography for the decline of French painting, the corruption of European taste, the fall of Western civilization. What would he have thought had he known that his hero, Eugène Delacroix, was an ardent student of photographs, that the painter used to send models to his friend Eugène Durieu to be photographed in specific poses to clarify anatomical proportions—how an elbow, for example, leads to the shoulder, in *Small Odalisque* (Niarchos collection, London), and how such passages are translated by the lens from three-dimensional flesh to two-dimensional paper? I doubt that Delacroix would have confessed to, much less expanded on, the practice with fierce young writers such as Baudelaire. Nor, for that matter, would Courbet, Manet, or Munch be apt to publicize their similar reliance on such "documents." An artist using a photograph was offensive to nineteenth-century vanguard as well as establishment taste, it was somehow illicit, like a taboo shortcut across the work ethic. A painter's image was supposed to grow in tentative, then defining pencil marks, in accretions of brushstrokes—a hand-to-eye cartography. The introduction of a photograph into the procedure was considered a cold touch of death. Its "literalism" (as against "realism"), said Baudelaire, and its reliance on mechanical devices, forever precluded the technique from serving an artistic imagination or entering the impalpable domain of creativity.

Once you understand that Delacroix used photographs, you begin to sense them behind his paintings. As you do behind Eastman Johnson's, who found in the lens's precise resolution of single-point Renaissance perspective a way to render such complex shapes as the spoked wheels of a baby carriage or the plaster work of a neo-Rococo ceiling, in his *Not at Home* (Brooklyn Museum, fig. 1). It would

5

have taken Johnson weeks of labor and quarts of sweat to arrive at comparable formulations with compass, pencil, and ruler. Johnson's perspectival projections are different in kind from historical Renaissance proposals—from Alberti's or Piero della Francesca's diagrams, for instance, or from Eakins' elaborately calculated oarsmen. There's a strong sense of the lens to Johnson's image, to its atmosphere. It can be read in his drawing, of course. It also can be observed in the disposition of values. Darks move to lights in systematic *glissandi*. A feeling of life's ponderable mechanics underlies the artist's scrupulous accounting for everyday trivia. You sense a fatality, implied by the camera's "nonhuman" intervention, by its control of the patterns of lines and layout, of how the image develops, by how the woman, discovered as she leaves the scene, feels and acts. For such artists, the photograph became more than a document or source of detailed information; it affected the look and content of their art (as it affects such brilliant contemporary Photo-Realists as Malcolm Morley and Chuck Close). The same held for Vuillard, Eakins, and Degas, all three of them wonderful photographers. And you can multiply examples—Charles Sheeler and Ben Shahn were professionals; the images in their paintings often are soaked in metaphysical hypo; Tchelitchew used the distortions of a telescopic lens; Surrealists borrowed juxtapositions from Atget; in Man Ray and Moholy-Nagy it is hard to tell which to admire more —the photographers or the painters.

Far from being independent mediums, each with its ineluctable manners and ineffable prerequisites, painting and photography have co-existed in (usually secret) mishmashes of borrowings and rip-offs, penetrations and misinterpretations, for over a century. The tacit embrace in mutual symbiosis has become more apparent in the past few years as painters have begun to work directly with photographic materials and as photographers engage in painting, until no one can tell with any conviction which is what. One issue is clear—a rigid conception of Art, High or Low, is useless to the discussion. A category that admits Andy Warhol's portraits of his mother, for example, and rejects the photographic transfers to canvas upon which Warhol based them, is mere pedantry. "Art" may be a useful word, I'd be sorry to see the handle discarded. In the art and/or photography debate, however, it's unenlightening when not misleading.

Aaron Siskind is a key figure to the development of modern photography. As is well known, he made photographs in 1943-45 that eerily predict some of the formations Franz Kline would paint in 1949-50. In 1950, while Willem de Kooning was struggling with the first of his series of monumental "Women," he kept by his work area a print that Siskind had given him. "I learned a lot from it, Aaron," he told the photographer who was visiting the painter's Fourth Avenue studio one afternoon. Twenty-five years later, looking at the photograph, it's not hard to deduce what attracted de Kooning to it (fig. 2). The image confronts you, head on, with an old sheet of waste paper—trash, lying on a sidewalk; it is crumpled,

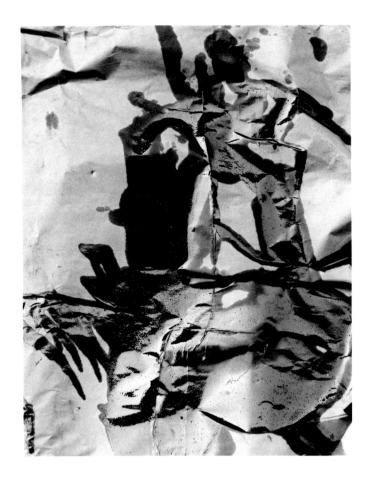

(fig. 2) New York 1950 AARON SISKIND

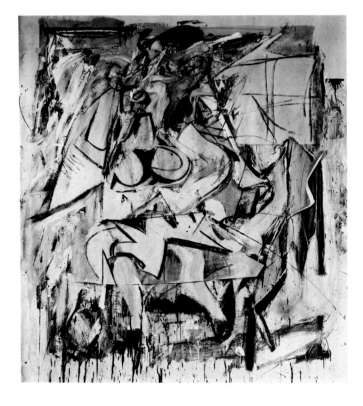

(fig. 3) Woman 1, Stage 1 1950 WILLEM DE KOONING

6

stained with oil. Siskind transformed it into a lyrical meditation on the possibilities of shallow "virtual" space caught on a flat "actual" plane—that is, of dented bulges and valleys, an inch or two deep, projected to the flat svelte surface of a photographic print. A photograph of de Kooning's *Woman I* (which wasn't finished until 1953), taken in the summer of 1950 by Rudolph Burckhardt, indicates how near Siskind was to de Kooning's train of thought (fig. 3). The painter had applied sliced sheets of plain brown "butcher's paper" to the canvas, on top of still-wet oil colors (as he often does for difficult works-in-progress). And he painted heavily on top of the sheets, drawing, correcting, effacing, and reconstituting the image—the figure's neck and breasts are on one piece, and a skirt-like shape, from waist to just below the knees, make a second section, the mouth is cut out from a mask. Some of the areas have a suggestion of trompe-l'oeil, as if they, too, were pieces of pasted paper. Moving away from the Cubist planes of his earlier "Women" (1947-49) to linear vectors and blazon-like elements that seem to bend and dent as they push together, crowding background recessions out of the field, de Kooning must have been surprised and gratified to find that Siskind had discovered in the streets prototypes of his vision. And Siskind's image isn't a simple *objet-trouvé*; he has emphasized unsettling "jumps" of value, similar to those that concerned de Kooning, as well as similar maskings of stroke and cuts from white to black that eliminate distinctions between negative and positive shapes. Read as wholes, Siskind's image shares with de Kooning's a sense of taut, flattened modeling, a will to strong, Michelangelesque controposto, fixed on the picture plane by a net of contradictory spatial clues (i.e., clues that signal "up" and "down" or "in" and "out" at the same time). There are certain passages (such as the circular shape at the lower right of the Siskind photograph and the "arm" to the right of de Kooning's figure) in the photograph which seem to predict shapes in the painting.

De Kooning and Siskind are obsessed with ambiguous poetics and contradictory tropes. The painter worked out the shapes of *Woman I* in three anxious years of work (1950-53). The photographer recognized his concepts materializing along the pavements during slow walks through the city in 1950. Both were deeply attracted to the vitality of New York as a place (or, as de Kooning would say, as "no place")—with its glamor, its filth, the dazzle of its lights on honkytonk and garbage. In 1950, New York did seem like the bright capital for a new life, in spite of (maybe in part because of) the rubble, decay, and built-in viciousness.

It should be emphasized that the image in Siskind's photograph is not a found object—not a happy accident uncovered like a rare shell on the beach. He takes his time to locate and familiarize himself with a site. He walks around it, studies it. Then an "object will *crystallize*," he says, or a detail, or a formation. He sees a "concrete, specific form, with a character that is special" to him. He looks at it "with total absorption" for a time—perhaps only a few minutes. Then come the technical procedures of taking its photograph, in

which the "character" of the subject is clarified. In the print he gave to de Kooning in 1950, for example, he modified the values—the moves from gray to deep black with scatterings of white—by his choices of methods of developing and printing . . . an infinity of options in between the image defined in the darkroom and the scrap of waste lying on lower Broadway, where everybody walked on it and over it—everybody but one man.

"An infinity of options"—or was it a fatality that permits only certain very limited decisions? When you look back, there was just one way, there was only the infernal machine of one life. Aaron Siskind's began in New York. He was born on December 4, 1903, to a family of Ukrainian immigrants. They were poor. His father was an independent-minded tailor who found the monotony of the shop difficult, and so became the proprietor of a succession of neighborhood shops. His mother kept house for him and their five children. His parents were, he recalls, "non-intellectual." They spoke Yiddish together.

The first-generation of American-born children, who grew up with the century, found a golden age for intellectuals. A *wünderkind* if there ever was one, Siskind became involved in everything from sports to radical politics. He played baseball. He made speeches, knew the cadres, was an underground gofer. By 1921, when he graduated from De Witt Clinton High School, he was filled with adolescent crises; he was disillusioned with politics, he recalls, and, suddenly, he couldn't even catch a ball.

He matriculated at C.C.N.Y., probably the lushest hothouse for intellectuals of the time. He was interested in music and writing, he collected records, went to recondite concerts, wrote verse in a Romantic-Symbolist vein—passionate, rueful, over-seasoned: Swinburne-on-Convent Avenue. He became friends with Barnett Newman, then an aspiring painter, and with Newman's friend Adolph Gottlieb, who was already painting full-time, and others. He joined the college literary society, Clionia, published verse in the literary magazine. In 1926, he graduated from C.C.N.Y. He taught in the elementary schools of New York until 1949, when he secured the first of three appointments at the college level as a professor of photography. He stopped teaching in 1975, retiring from the Rhode Island School of Design to a house he'd bought nearby, in Providence, R.I. He still sees and enjoys students. He was, you sense, a natural teacher, an inspiring professor. Still, it was a drain.

If school work was exhausting and distracting from Siskind's major interests, it saw him through the Depression. His wife also taught and together they could afford a pleasant apartment, part-time help, and what started out as a hobby for Siskind—photography. In 1932, he joined the Film and Photo League, a club of professionals and amateurs most of whom were oriented firmly to official Communism—a typical, 1930s, intellectual's approach to radicalism. The Communist Party, at one time or another, attracted almost every important artist, writer, and musician in Depression

New York (the painters ranged in style from Stuart Davis to Rockwell Kent). At the Photo League, members called one another "comrade." One of Siskind's earliest memories of its sessions was the "trial" of one Izzie Lerner, accused of speaking ill of the "Workers' Homeland" (the U.S.S.R.). Izzie was found guilty, expelled from membership, and, in solemn judgment, the workers of the world were warned to have no further commerce with him. At first, Siskind was able to ignore its dogmatic pressures, and he concentrated on learning what he could about camera techniques and darkroom procedures—a fellow member helped him set up his own developing lab in a closet. Also, the League was one of the few places in New York where you could meet photographers—Siskind recalls that Paul Strand and Berenice Abbott came to the League a few times—and where you could look at photographs. The work was largely unavailable to the public. Siskind first saw Walker Evans' photographs in a literary magazine, *Hound and Horn*, that he had bought for its poetry; he saw his first Stieglitz prints at the Anderson Galleries on Fifty-Seventh street. He didn't know about the Stieglitz cénacle and gallery, 291, until much later.

At the League, Siskind worked on its traveling shows, which were circulated to trade-union and Communist Party headquarters around the country. In 1935, Siskind found the bigotry and authoritarianism at the League intolerable, from both a political and aesthetic viewpoint. He left it in disgust. In 1936, he was invited back and formed what became known as the "Feature Group." Under his leadership the group explored through a series of exercises the aesthetic of documentary photography—which, Siskind believed, should be objective, restrained, matter-of-fact, balanced, careful, avoiding the easy poetics of artiness and "irrelevant beauty." He sought to continue the traditions of Brady, O'Sullivan, and Atget through the insights of such twentieth-century champions as Evans and Abbott. Working together for over three years, the group produced a number of studies of New York life, and with a black writer, the larger "Harlem Document." Working independently during those years, Siskind completed a study of an austere Protestant retreat in Martha's Vineyard ("Tabernacle City"). It was more architectural than humanist in feeling, and was attacked as "formalist" at the Photo League, which he quit in 1940. Then came a fallow period, a time of anxious silence (that also marked the careers of most of the Abstract-Expressionist painters). Siskind hit his stride again in 1943-44, with the so-called "abstract" photographs that characterize his mature style. Still, the documentary experience was never forgotten and it remains near the core of his sensibility.

Consider the abstract works as documentaries—including the recent photographs in this book. They are in what could be called an "interrupted serial" form. Siskind will find, and then return to a motif over and over again: a certain tree, seaweed dried into the most automatic of drawings on a Martha's Vineyard beach, a favorite stone wall. Years may intervene between one image and the next,

between visits to a site. Yet the serial (or documentary) context has relevance. There is a similar accrual of imagery, a depth of reference. The serial drama concerns small changes, critical shifts. Each version informs the next one. Shapes become luminous with meaning. They convince. Just as his documentary photographs arrived at a "truth" —a factuality—through accumulations of evidence (the disgrace of Harlem living conditions, the spirituality of naïf religious architecture), Siskind's later, abstract photographs convince you of the authenticity of his vision through a multiplicity of signs—in space and across time. You understand his tree; you seem to have known it for as long as you've known the palm of your hand.

Siskind's abstract work shares with his earlier documentary photographs a sense for limited time and restrained motion. It establishes a complex interior dialogue between *stasis* and *praxis*, between the calculated articulations of a rigid black, gray, and white composition and your comprehension that these balancing elements are also lichens, mosses, spores, decays, growths, and other intimations of the dynamics of mortality. From the documentary concept, too, comes the poise of a cool, objective, studious observer— James Joyce, perhaps, with tripod instead of walking stick. There is little of the hot flash of photo-journalism in these icy prints or of the theatrical heavings common to most photographers of nature—even to the best of them (Ansel Adams comes to mind, with his Ferde Grofé Grand Canyons). In short, Siskind's static-looking images document a pullulation of small actions which, if you glance too hurriedly, or without understanding, are invisible.

Also, there is the photographer's need to return, season after season, to certain specific subjects, just as Ingres would go back, over and over again, for a lifetime, to certain poses of the nude, to certain turns of the neck, undulations of the spine. In the Middle Ages, there was a monk's disease known as *delectatio morosa*. Sheltered by monasteries, by erudition and spiritual canticles from the distressing heterogeneity of the world outside, in a sort of ecstatic possession, some brothers would go back, over and over again, to certain favorite subjects. They would polish them, reanalyse each part, reformulate the whole. There's an obsessional quality to *delectatio morosa*; more to the point, there's an intuition by an artist that he's left something precious unaccounted for, some sapphires still are lost in the mud of quotidian experience.

Siskind returns to old themes because, when he's become thoroughly familiar with a hypothesis, he then can let his imagination soar at liberty. By fully accepting the *donnée* of a motif, he's free to concentrate on his art. The monks were criticized by their superiors because they were creating art instead of a religious experience. Artists such as Ingres, Cézanne, de Kooning, and Siskind, are lost in art; they return to favorite subjects like a dog to his old bone, to familiar themes, reviving them, worrying them, putting them through all possible variations and dislocations. Artists and monks have similar contemplative, scholarly, original, cantankerous temperaments.

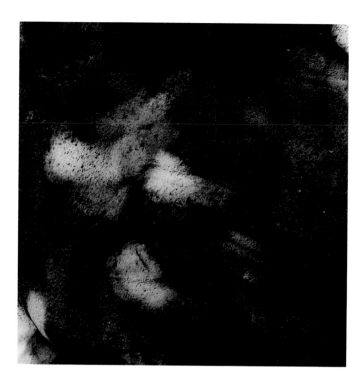

(fig. 4) Villahermosa (Olmec) 5 1973 AARON SISKIND

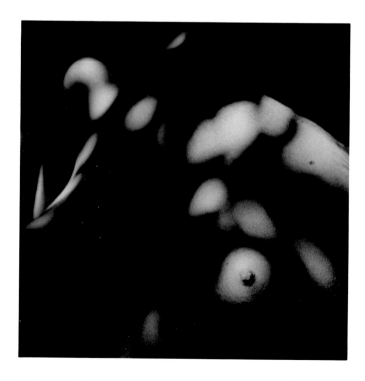

(fig. 5) Louise 31 1974 AARON SISKIND

They are concerned, like Proust, with memory. What can better symbolize the enigmas of mnemonics than the weaving gestures of eternal return?

Siskind, of course, keeps himself open to fresh experiences; indeed, he has perfected certain disciplines to keep in contact with the unfamiliar. Once, for example, he set himself the assignment of walking from his studio at 47 East Ninth Street down to the corner, with the goal of discovering six new subjects. Usually, however, new subject matter evolves from previous insights. In 1973, in Villahermosa, Mexico, in an outdoor museum of Pre-Columbian sculpture, Siskind took a photograph of a monumental stone Olmec head (fig. 4). Sunlight, falling across the convex features, camouflages a nose, lips, eyes, under shimmerings and spots of shadow. The following summer, at Martha's Vineyard, Siskind had a model take a series of poses, naked, in the woods (fig. 5). Her body, beneath the leaves, reminded him of his vision of the Olmec head. And both images recalled one of his favorite poets, Gerard Manley Hopkins—"Glory be to God for dappled things . . ." A sternly regal head and a sensuous young torso are conflated to a single vision of "pied beauty." Siskind often works to transform the most disparate "object matter" (the phrase is Barnett Newman's) to a unitary, visual system. Like Kierkegaard, he dreams about a "will to one thing."

Almost all of Siskind's photographs evolve from earlier photographs—just as art comes out of art. The Olmec head informs the nude. They become two glimpses of a perhaps unattainable synthesis. Thirty years earlier, Pre-Columbian art quickened Siskind's vision in an even more crucial way. In the summer of 1943, in Gloucester, Mass., he and his friends used to sun themselves and stroll on the Bass Rocks, a strand of rugged, granite boulders. The following winter, Barnett Newman was organizing an exhibition of Pre-Columbian sculpture for Betty Parsons at the Wakefield Gallery, and he asked Siskind to photograph some of the objects. Siskind studied them with serious intensity. The following summer he returned to Gloucester, walked along the Bass Rocks, and suddenly, he recalls, the stones assumed something of the magic of Pre-Columbian sculpture. He glimpsed a common, basic substructure. And he made some of his first "abstract" photographs—"abstract" in double quotation marks because these unpeopled patterns are of real rocks that allude, through an artist's epiphany, to a famous, figurative, symbolizing, religious art.

Which raises the vexing question of associations: you look at a Siskind photograph; you enter the artist's universe—ordered, calm, elegiac, darkling, forceful. You look around and feel the strong articulation of abstract shapes. ("He counts too much on Art," says a younger detractor, a connoisseur of the *désinvoltures* of snapshot formats—our latest fad; Siskind is almost never casual; even in the wonderful series of boys diving into Lake Michigan, he insists upon a classic framing space.) As in the paintings of his friends Franz Kline and Willem de Kooning, the structure of the image delivers the initial,

dramatic impact. Next, you wonder, "what" beast was in view—at what did Siskind aim his camera?

"And what might *that* be?" the painter Landes Lewitin rumbled loftily, pointing to one of Siskind's photographs at the Egan Gallery in the early '50s.

"It's a picture!" said Siskind laughing, swiping the age-old dodge which painters use to avoid talking about subject matter with amateurs and nosy strangers.

Lewitin pretended to be furious—hoist by his old cliché.

Still, it's a good question. *What* is a nude, an Olmec head, a stone wall, some trees? Obviously. Then the naming game becomes a little harder—bits of graffiti and torn poster, broom growing on a hill outside Viterbo, olive trees in Corfù, whitewashed stumps in Vera Cruz, flies on the back of an old horse, details from the Arch of Constantine. The subject tends to hide within a composition that Siskind has isolated; it melts into strong diagonals and balancing systems of gray. Which leaves its identity floating, riddling, a free target for associations.

Spectators have been known to muse (sometimes in print) in front of a Siskind photograph like analysands in front of ink blots. They identify images of Good and Evil, Eve and Adam, making love and making war. And they are apt to ramble on, cheerfully locating further themes within smaller details. It's an exercise that would be inappropriate to almost any painting. Painters want to control what and how the spectator sees. They censor out unconscious symbols and Freudian configurations as such imagery rises to the surface. Indeed, a good way to tease a painter is to indulge in excessive reading-in. Ad Reinhardt once said to Robert Motherwell, "That picture looks like a picket fence around some farmyard in the snow." "Please," said Motherwell, "keep your simple-minded associations out of my fine art."

Siskind, on the other hand, seems to enjoy the richness of allusion a widely ranging interpretation can bring. Looking at a photograph of an olive tree in Corfù, he talks about its "womb" or "belly" shape. He defines recurrent typologies. There are pictures he calls "conversations" (often of two elements, about the same size—two rocks, two branches); others take a formation he's named "mother and child" (a larger shape cloaking a smaller one); still others are "trinities" (triadic, hieratic arrangements). And, of course, there are his well known, generous "Homages to Franz Kline" in which many of the painter's favorite motifs are isolated: the central square, the taut, calligraphic edge, the energetic spill of black or white, the emphasis on negative spaces.

Beneath any cosmetic likeness to the Abstract-Expressionist surface lies Siskind's dedication to the ambiguous, the allusive, the extended metaphors implied by chains of association. It is as if the glassy skin of the photographic print—as against the roiled textures of Franz Kline's oils—defined a locus for fantasy and dreams.

Siskind shares with the Abstract-Expressionist painters a tough, dialectical approach (honed, of course, in the hard-knocks school of radical politics). He emphasizes the polar tensions in almost all his images. Kline worked with a dialogue of black and white, of line and shape; in Newman's paintings, there's almost always an opposition of freely painted elements and tightly painted ones—the aleatory runnel complements the tightly executed edge. Siskind is dedicated to similar metaphorical structures. In his first abstract photographs, made in Martha's Vineyard in 1943, he set organic objects in geometric contexts, establishing a dialogue between man-made objects and fragments of nature: a shell on the grid-like planking of a dock, for example. It's been a recurring theme in his work ever since. Twigs of dried broom twitch against a blank sky, suggesting the flames into which they might burst at midsummer when the fields are burned. The crisp vegetable coils are opposed to the tight, straight, emphatic rectangle of the framing edge.

Such are some of the cunningly plotted dialogues that can start free associations. Supporting them is a straightforward methodology, and in this, Siskind's approach differs sharply from that of the painters who formulated the grand style of Abstract-Expressionism. Their techniques—as I've written elsewhere, particularly in monographs on Newman and on de Kooning's drawings—are masked, hidden, mysterious, difficult to comprehend from the surface of the painting. It's hard to tell how a classic Pollock drip painting was created, or how de Kooning achieved certain jumpy passages, or Newman, various pulsing edges. In Siskind's photographs, on the other hand, all methods are open, frank; techniques are, in his words, "normal" and "usual." They articulate the image and the subject matter, just as, in International Style architecture, the inside of a building is articulated by the façade. In this important sense, Siskind's image is architectural rather than painterly, and has more to do with Mies than with Kline. That he spent many years teaching in America's transplant of the Bauhaus—the Institute of Design, Chicago—in alliance with Mies and Moholy-Nagy, is one of History's attempts at a happy ending.

Siskind usually works with a Rollieflex single-lens camera. It produces 2¼ by 2¼ inch negatives. What he sees on the ground glass finder is what he gets in the photograph. As has been indicated, he takes his time when he gets to a site, his "out-of-doors studio" as he calls it. He strolls around, alert, absorbed, a little like a skilled hunter or fisherman. He wants to know the terrain intimately. Usually he works with a tripod.

The scale in his pictures usually is geared to what he calls "normal" size and "usual" shape. It's something you can hold in your hand, read like a poem. Siskind's shapes are basically legible. Often they refer to type or to scrawled letters or fragments of letters. Details of architecture or trees or sculpture cleave to that module. Like the noble arts of Islam, Siskind's basic unit isn't a body in a noble athletic gesture (as it was for the Greeks), but a hand holding a pen or a brush and marking out letters under the attentive supervision of a fine eye for curves. It's a lyric scale, for a poetry to be seen.

He invites you to a contemplative study of ambiguous messages. The prints are made with affectionate craft; they repay extended pe-

riods of looking, even those (and there are many) which offer raw, dramatic impacts. They seem to come at you all at once, at a visual gulp—holistic Gestalts, like certain paintings by Kline and Newman; and, like them, Siskind's images open to many levels of understanding. The background (a wall, a beach) will differentiate itself, then intermediate planes will be defined, then foreground measurements, each perhaps only a fraction of an inch behind the other in "actual" depth, as in photographs of graffiti on torn posters or whitewash on a wall. The image has the labyrinthine intricacy of palimpsests. Like a palimpsest it offers simultaneity in space and time. You see the present with its integument of the past, and you begin to question which is which. The image fills with metaphysical tropes and traps. You're reminded of Donne's elegies, with their deadly laughter about the grave and his artifices to invoke nature.

Siskind's overtly simple, self-explanatory, "usual," "normal," techniques, which differentiate his photographs so sharply from the Abstract-Expressionists' paintings, and his everyday subject matter, with its close-ups and enlargements of bits of the average environment, combine to express still another factor—a complex image created from a synthesis of simple data. The emphatic flatness of the picture plane in most of Siskind's pictures, usually achieved by photographing a flat subject with the camera aimed perpendicular to it (a wall, the beach sand, a piece of paper, the white sky), sometimes conceals unsuspected vistas. Holes in an olive tree open to a view beyond, even though the holes are so consistent in texture and scale with other details of the bark that they look like gray material added to the surface—cement perhaps, or atmospheric chewing gum. They are different from wood; they don't look like air. Siskind likes to suck background elements forward to the picture plane by multiplying details and by judicious placement and variations of contrast, rather as an Impressionist painter marries a background sky with a foreground bush.

These modalities of ambiguity—games with space and volume—remind you that throughout Siskind's straightforward methodology are many places where the artist intervenes, where he decides how an apparently natural process should evolve. Siskind's prints don't grow like flowers, even when they achieve a look of inevitability. He will darken certain areas, lighten others, during the darkroom processes. He can increase value contrasts, crop off edges (one of the more comical aspects of the modernist aesthetic is that many of its devotees consider it a sin to crop photographs and a virtue to crop paintings). Siskind's images, for all their truthful airs and candid graces, are steeped in artifice—planned and geared to style, like any painting.

It's on this deeper level that Siskind's photography rejoins the great images of his time, and it's also where he stakes out his individual territory. Like his friend Newman, and like Rothko and Still, Siskind is concerned with the sensations of loss, of time passing, memory fading, mute suffering, death. Clyfford Still evokes midnight terrors and the paranoia of endless prairie spaces; Newman is concerned with a sense of the tragic at the heart of the sublime. Siskind is more

intimate, he treats small things, things that have a sense of belonging, even when abandoned (one of his most famous photographs is of a discarded glove, weathered by the sun, rain, time, and the recollections of a hand); he also has a sharp eye for announcements, posters, ads, and signs that are on the verge of disappearing. You think of high-flown statements, and of a young poet's insistence on the all-importance of his selfhood, the "I-Me" of graffiti, "I was here," "I existed," "Et in Arcadia ego . . ." The self asserts itself, at first loudly, then, as the wall gets abused and as posters fade, pausing, hesitating, quavering. Finally the text is lost in a static of other voices, other signs, a clatter of letters—the garbage of desuetude.

While he observes, with a documenter's objectivity, the death of things, and as he keeps his gaze fixed on ultimate humiliations, Siskind perceives with similar cool appreciation that a new life takes over—the lichens, molds, blooming cancers, enthusiastic bacteria. You are reminded of Baudelaire's vision of the carcass of a dead horse reborn in pullulations of flies and maggots. Only where Baudelaire was Gothic and squeamish, Siskind is surgical, calm, orderly. He accepts the grim protocols of afterlife.

Any descriptions of Siskind's photographs as symbols of death and rebirth (or resurrection; the crucifix is a recurrent motif in his repertory of shapes, but then it is hardly a rare configuration) should be held strictly accountable to the formal context of his images. About ninety percent of a Siskind photograph—of all photographs, for that matter—concerns shapes, values, disposition of perspective, warping of volume, articulation of edges, translations from three to two dimensions, sense of emulsion, feel of paper, emergence of darks and lights from chemical deposits in developing and printing. It's in a formalist area that Siskind's particular genius obtains—his ability to make photography a matter of transcendent aesthetic import. The finished prints should be considered as pure phenomena, matters of inter-relationships, of parts to a whole, the whole to the medium, the medium to its particular state of technological and philosophical self-awareness at the moment in art-historical time. This is what art is about. Still, granting that, beyond the controlling formalist issues, there remains another ten percent to be considered—the subject matter, the symbolizing magic, the evanescent nuances which give Siskind's oeuvre its particular flavor and peculiar timeliness. He may talk with History through his genius for shape and composition. He talks to us through our humanity—through his feel for the tragic.

Conscious of mortality, we honor Siskind for the purity of his vision—for a grand style. We love him for being like us, trapped within, and struggling against, time: the ½ second click of the shutter, the 15 minutes of agitated chemical baths, the 24 hours it took to locate a subject, the weeks for a twig to wither on a hillside outside Viterbo, the years for lichen to take over a wall in Martha's Vineyard, the centuries of wind and rain to lick smooth the marble emperors along the Via Appia—the lifetime of an artist at work, observing the ways of creation, finding hard symbols for its dim mysteries, in cool, firm, lucid imagery. "The language of flint and air . . ."

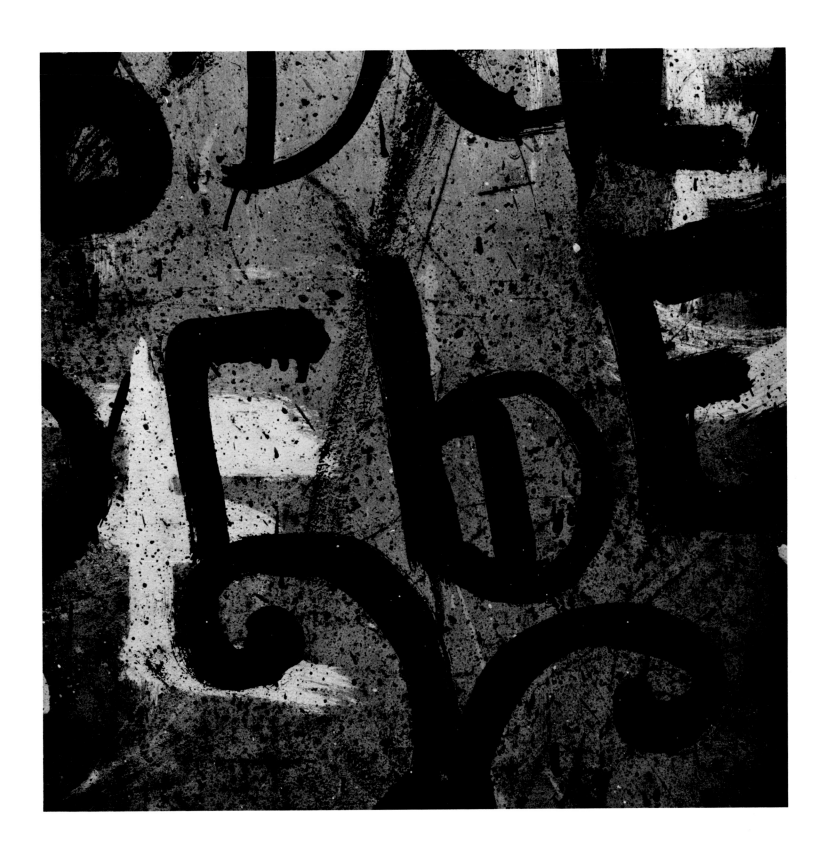

Coatzacoalcos 9 1973

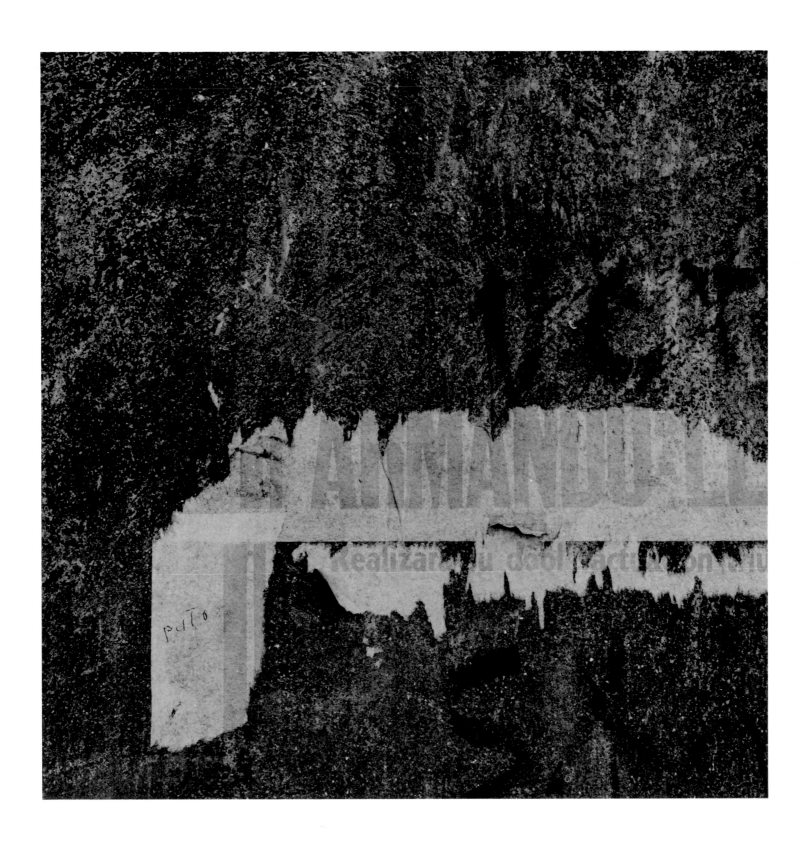

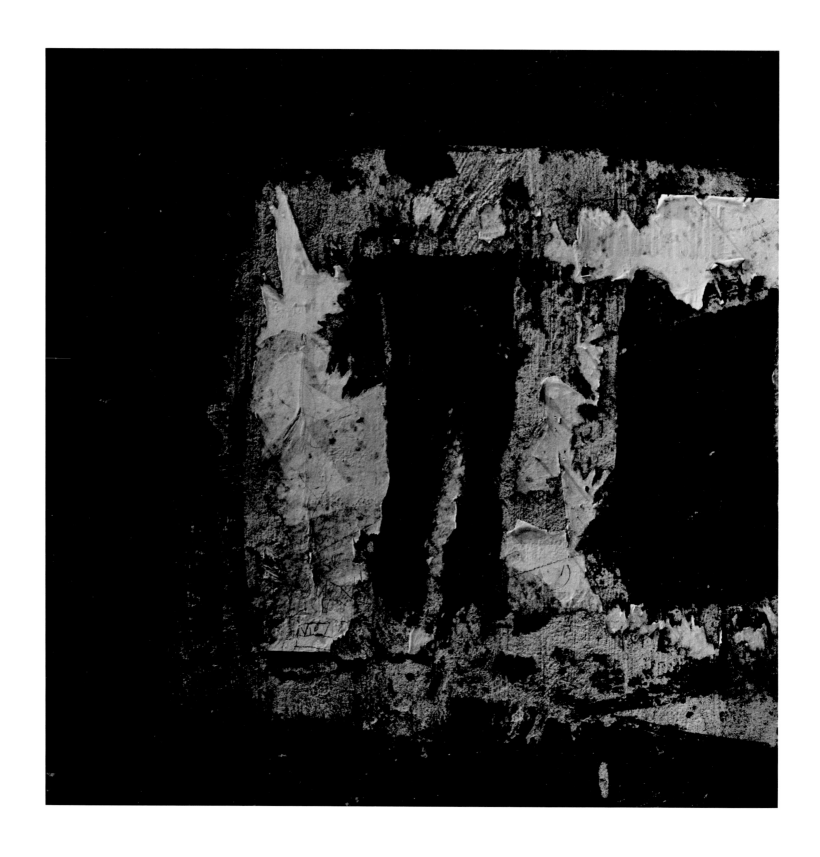

Coatzacoalcos 55 1973

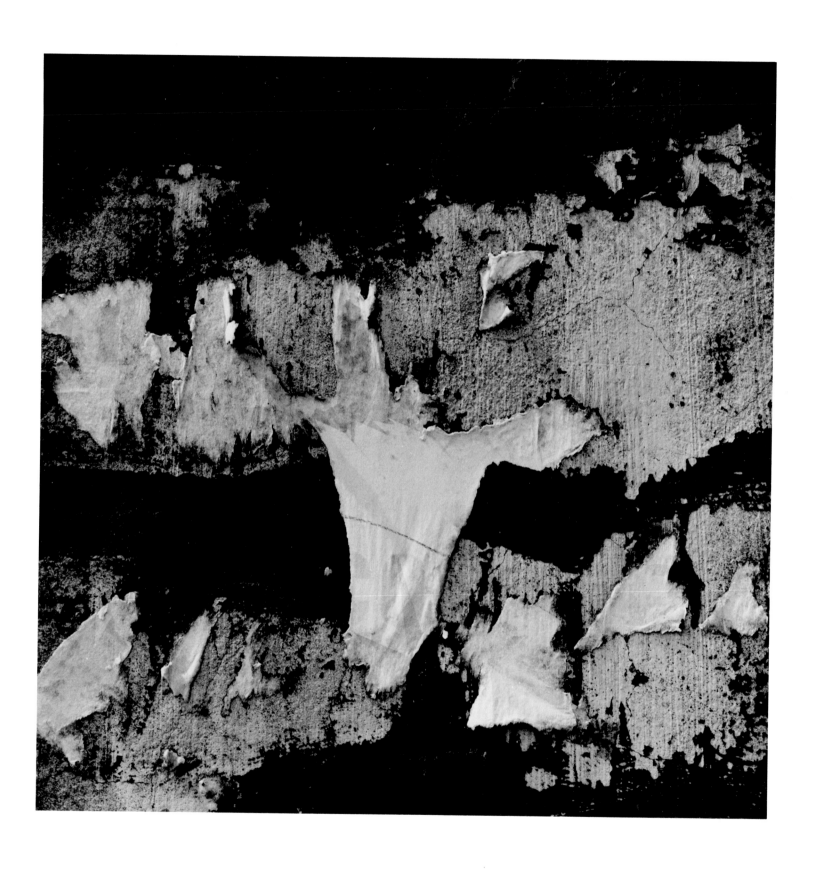

Coatzacoalcos 54 1973

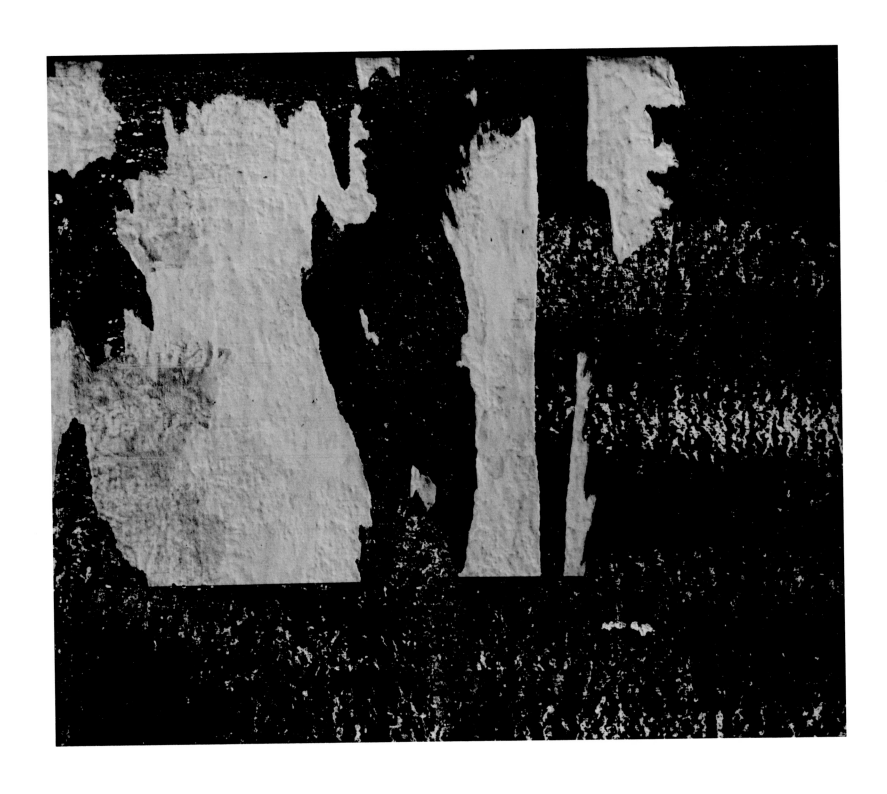

Merida 36 1974

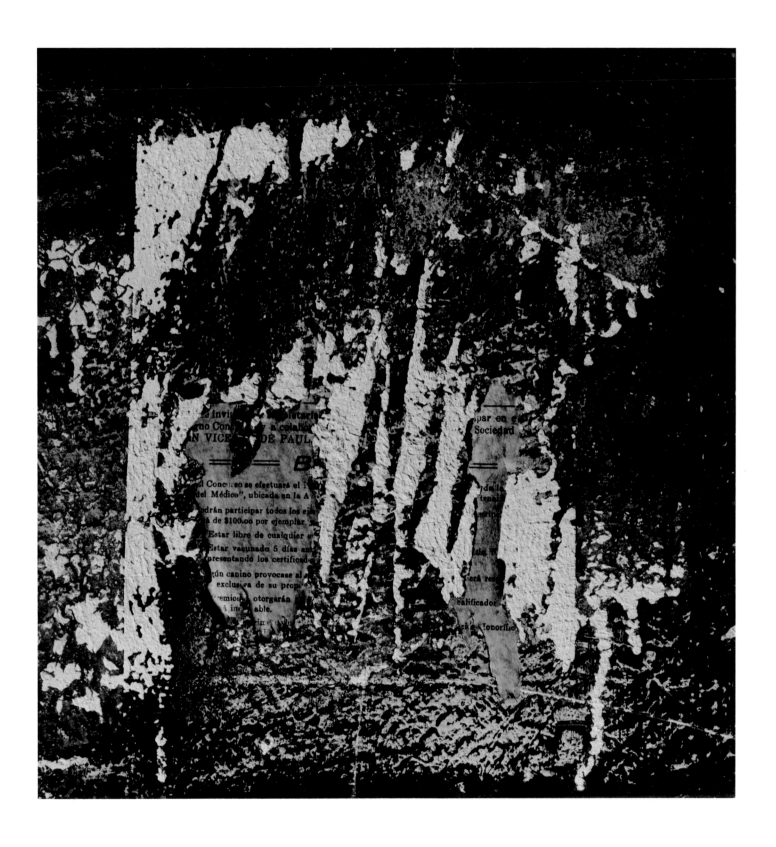

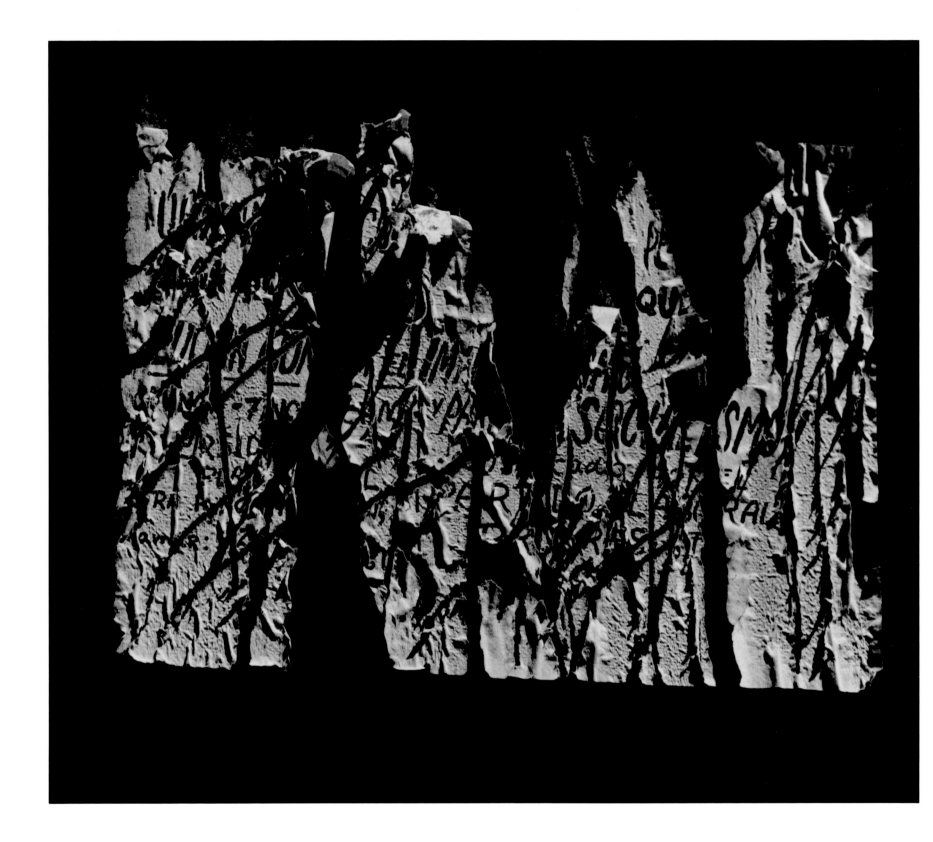

Boston 2 1974

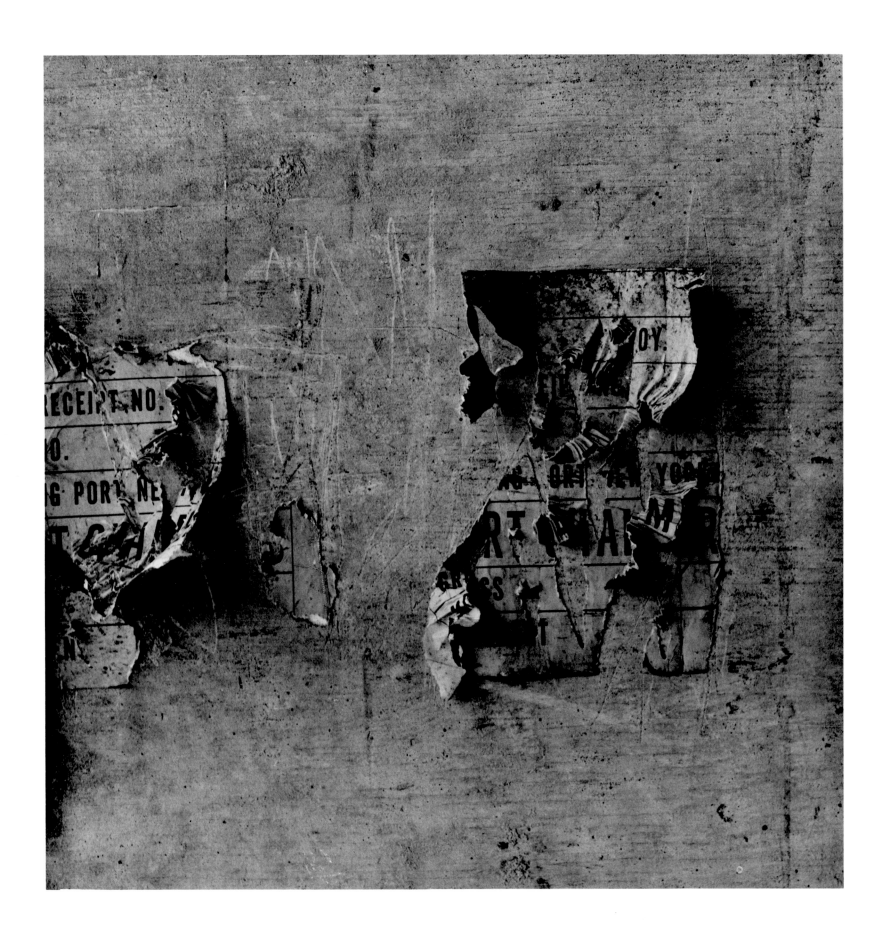

Boston 19 1974

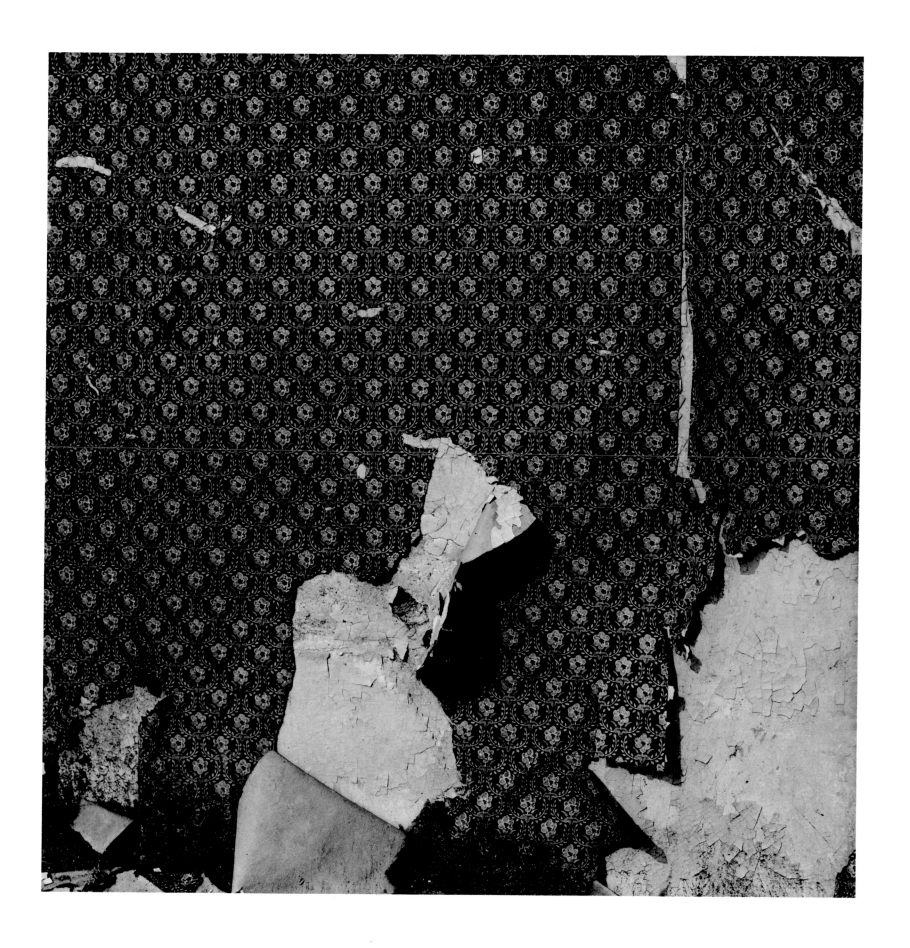

South Dakota 7 1970

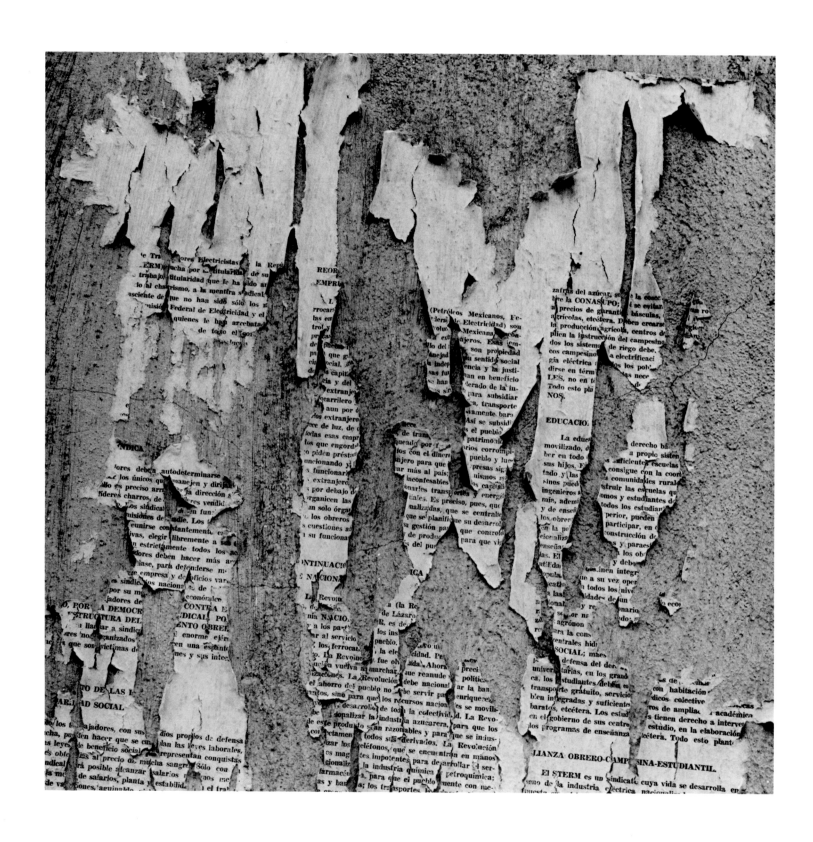

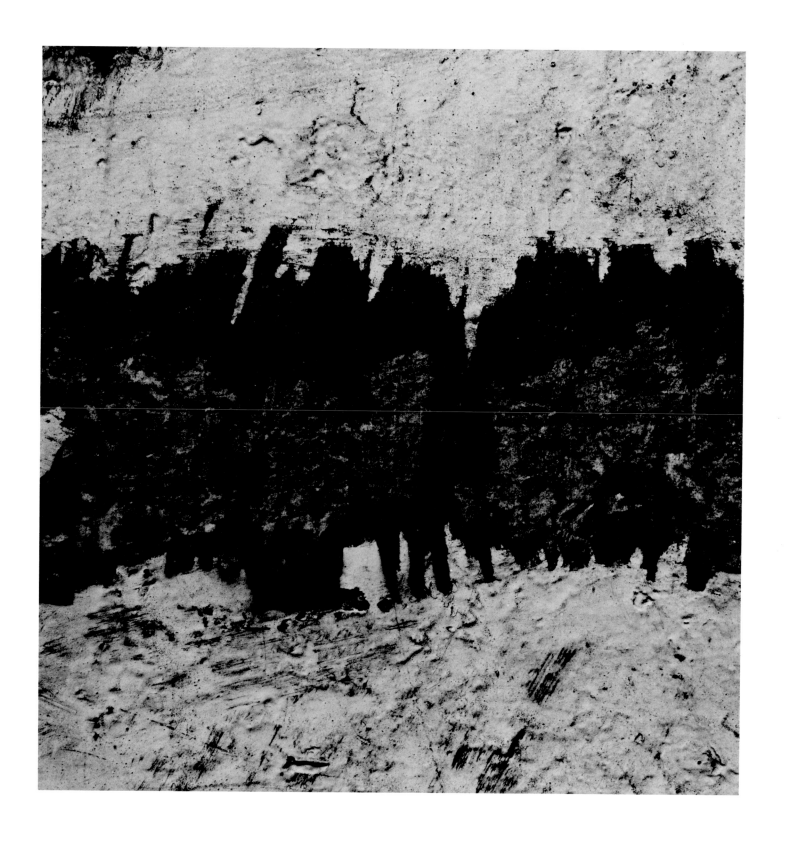

Vera Cruz 180 1973

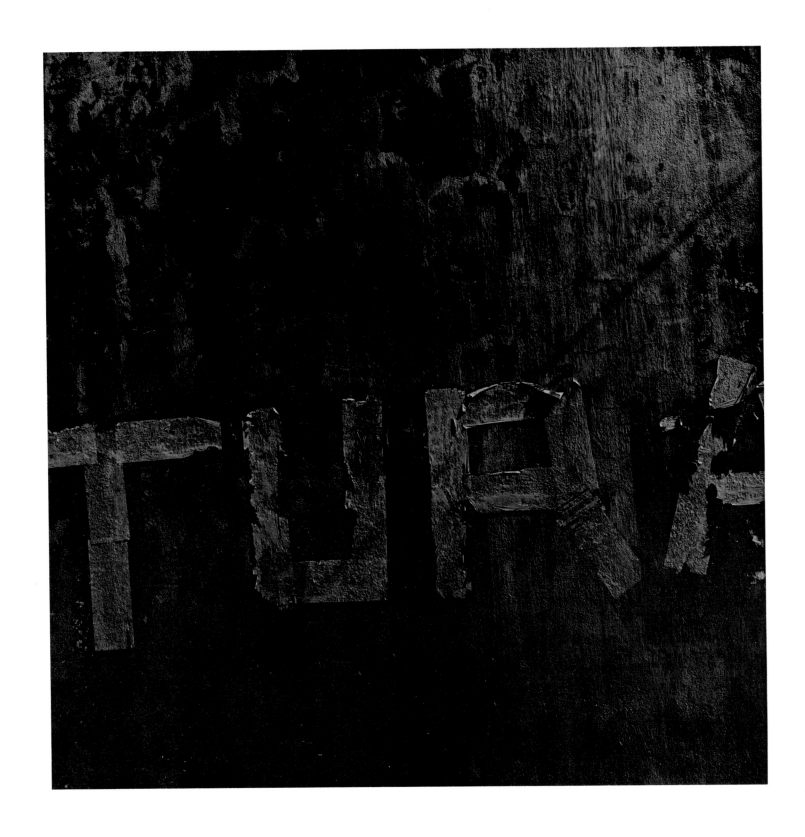

Vera Cruz 125 1973

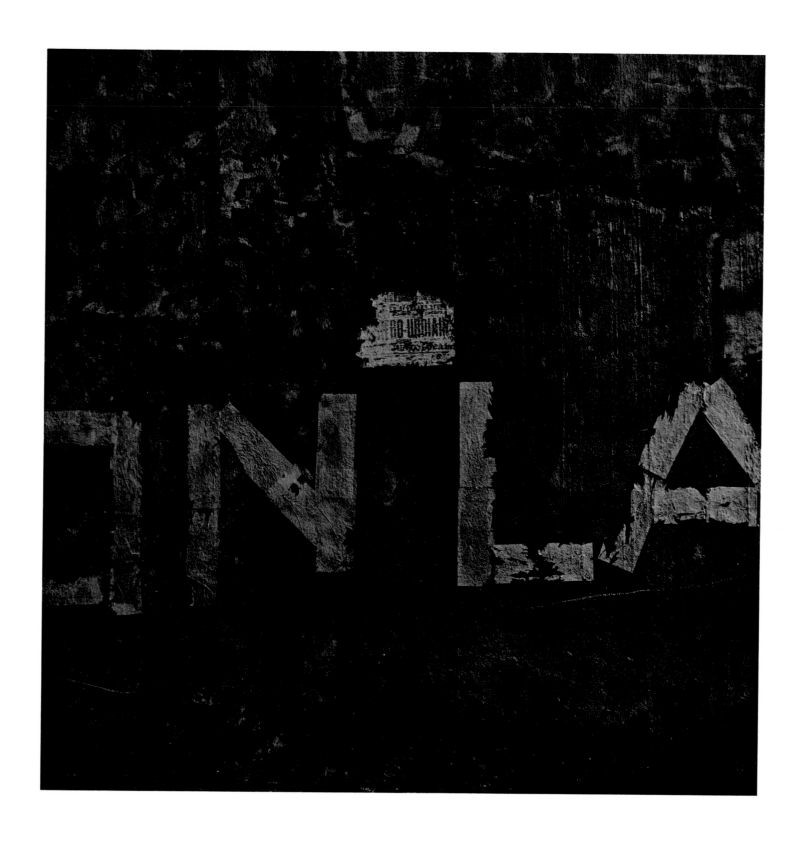

Vera Cruz 128 1973

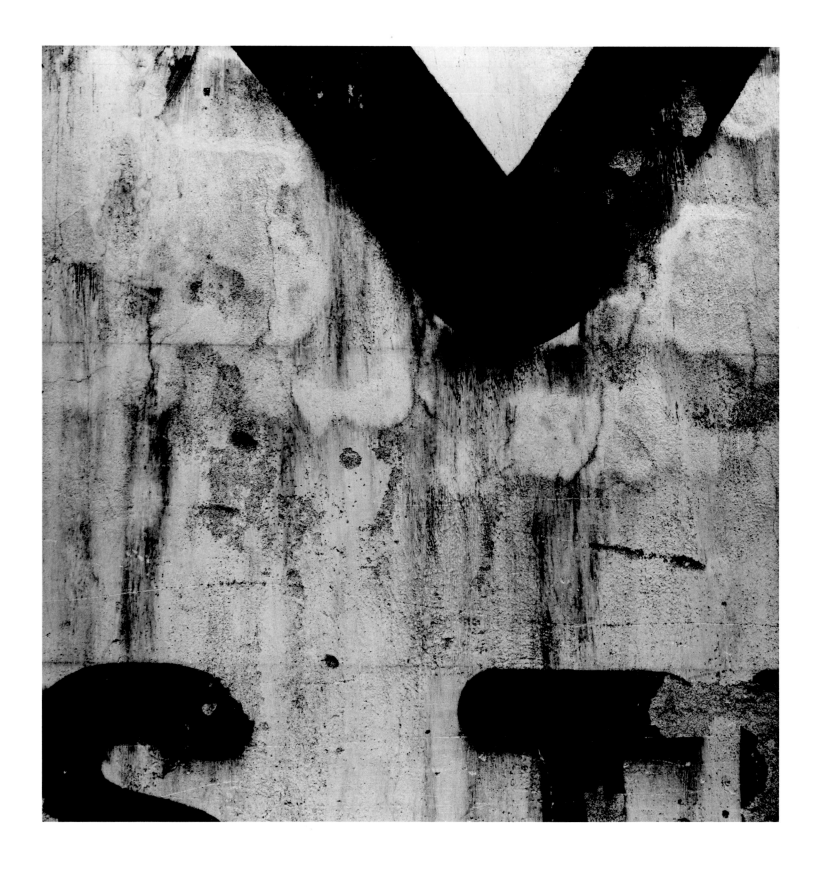

Vera Cruz 96 1973

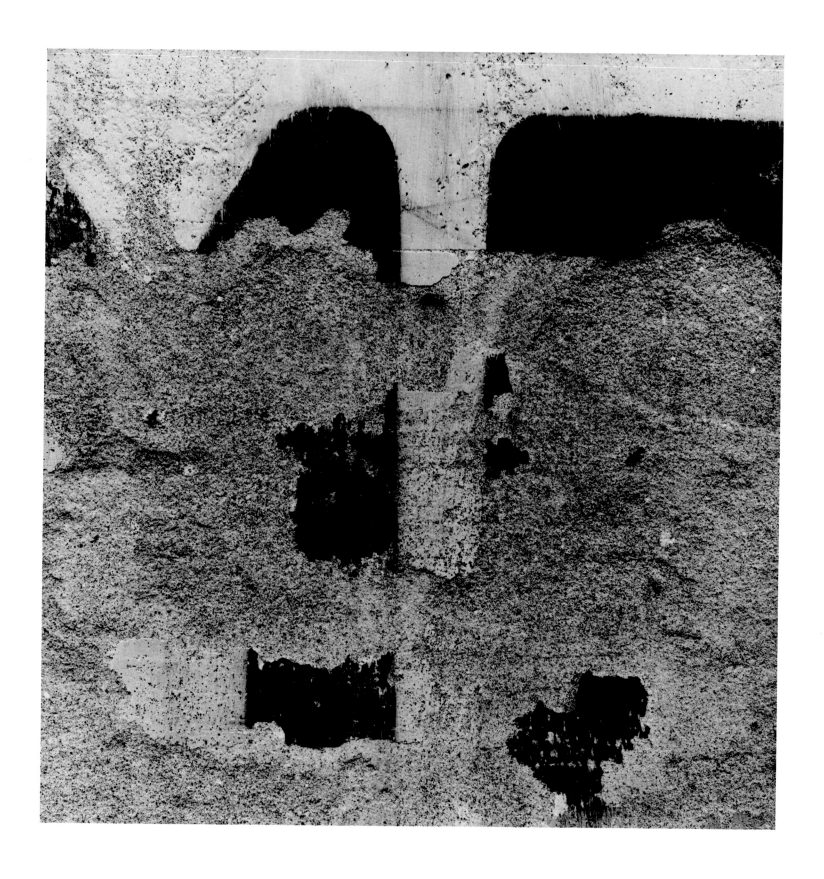

Vera Cruz 99 1973

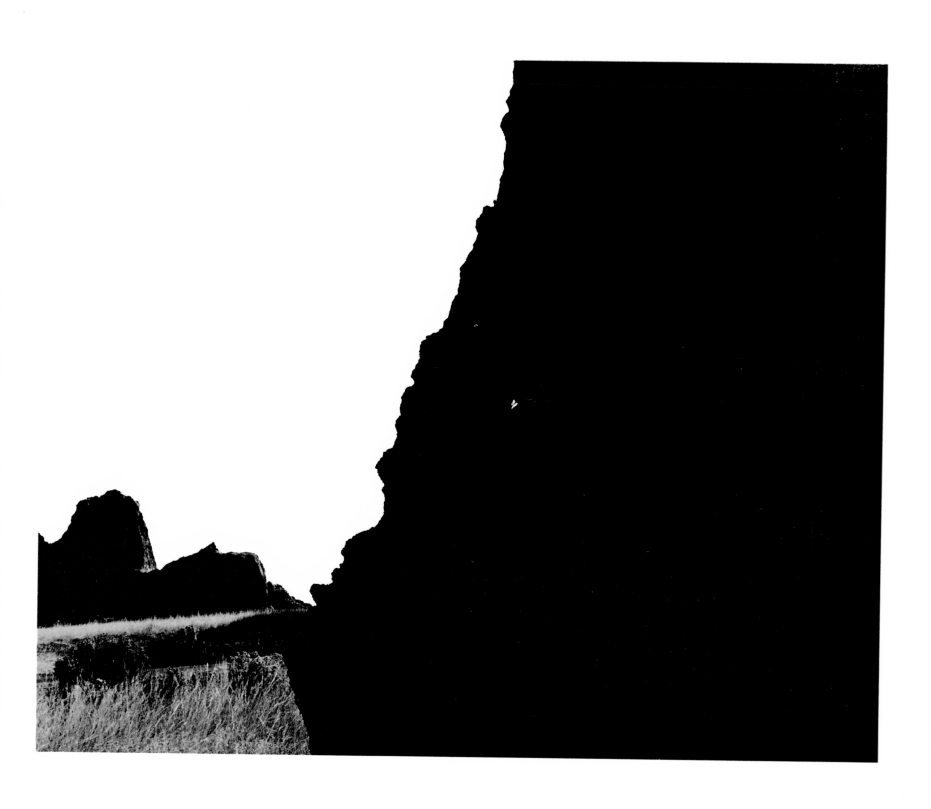

Badlands (South Dakota) 60 1970

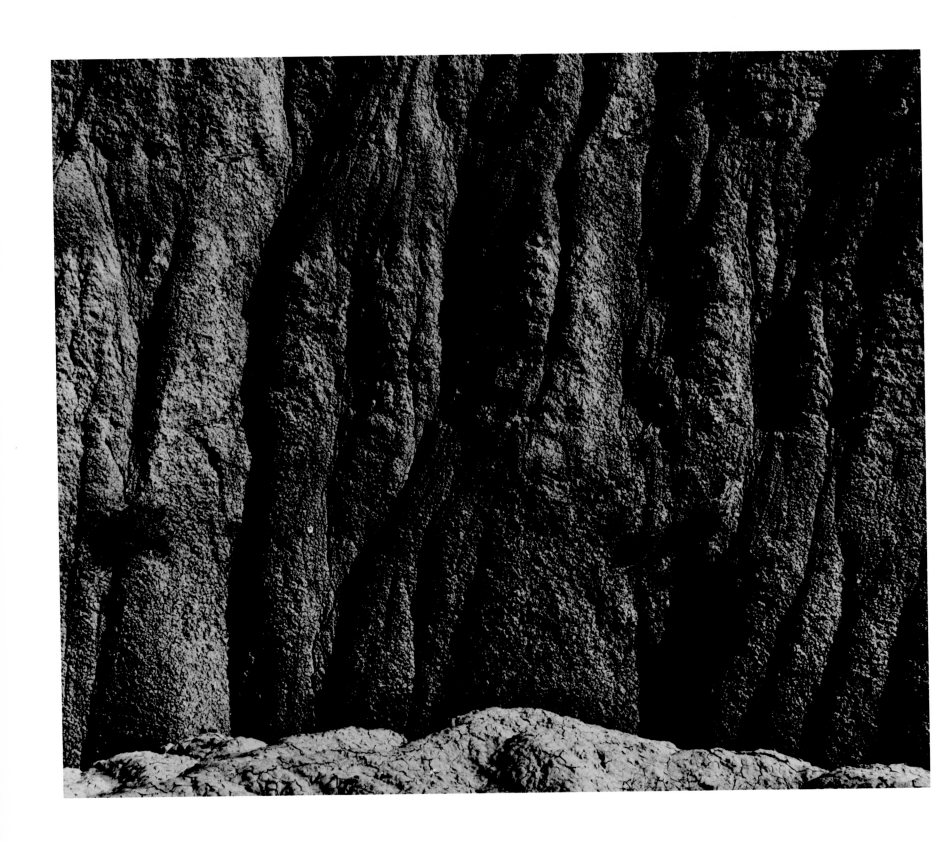

Badlands (South Dakota) 72 1970

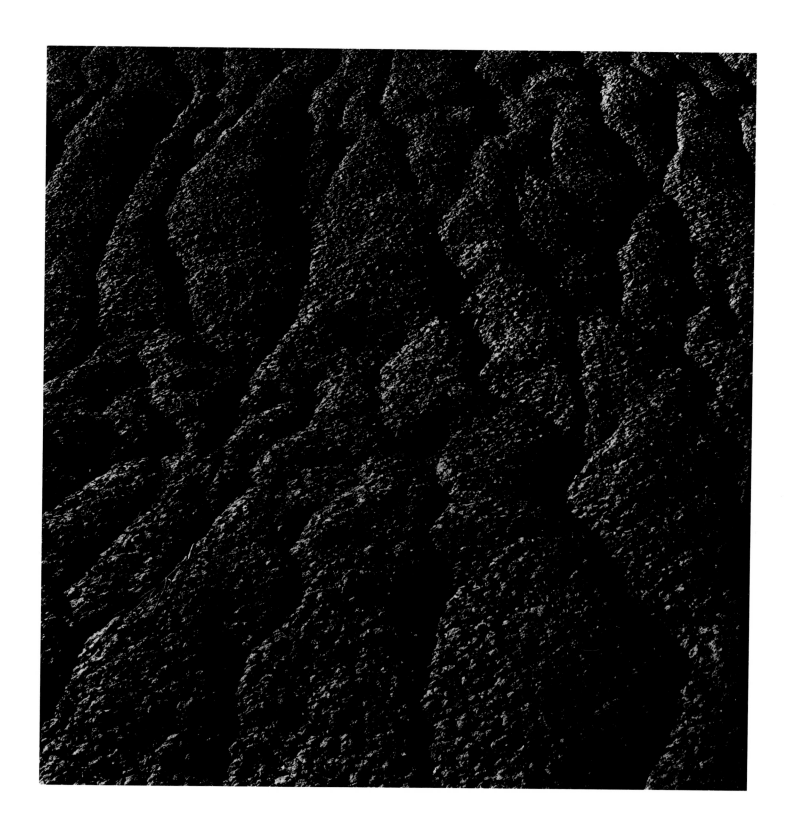

Badlands (South Dakota) 79 1970

Homage to Franz Kline page 35-65

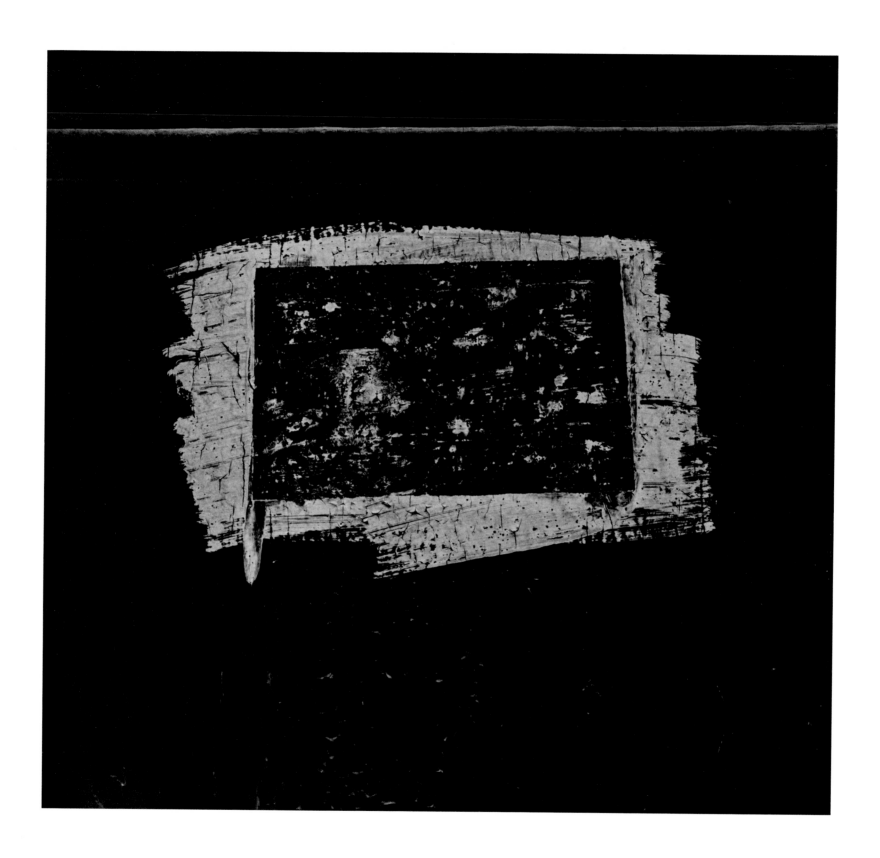

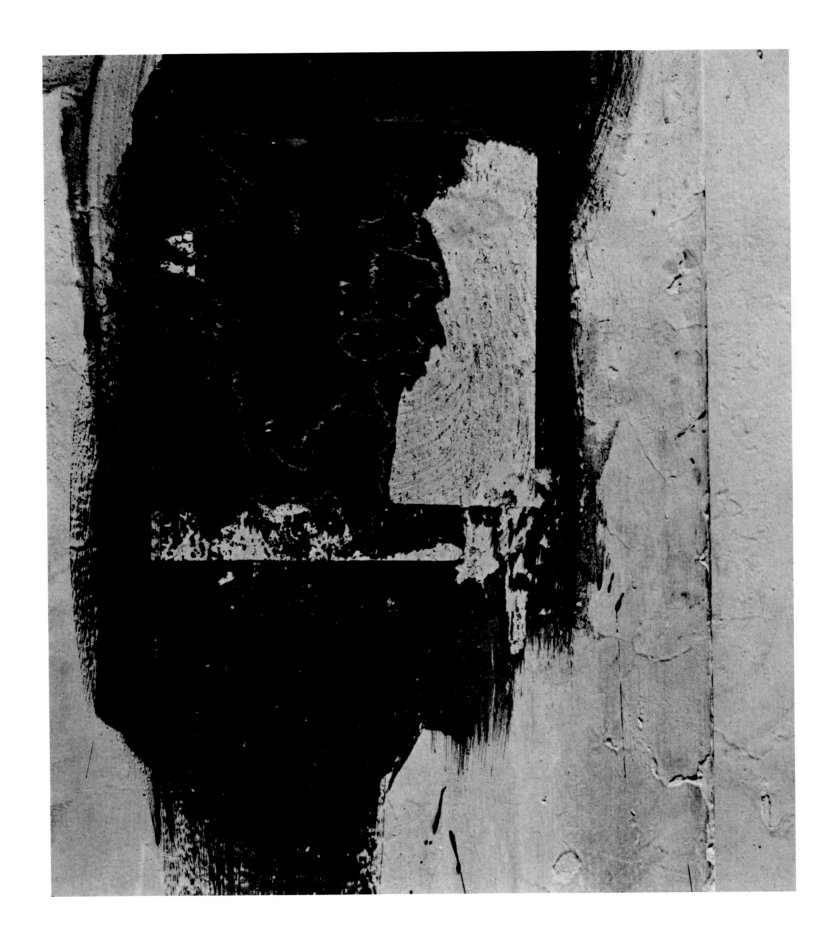

Lima 98 1974

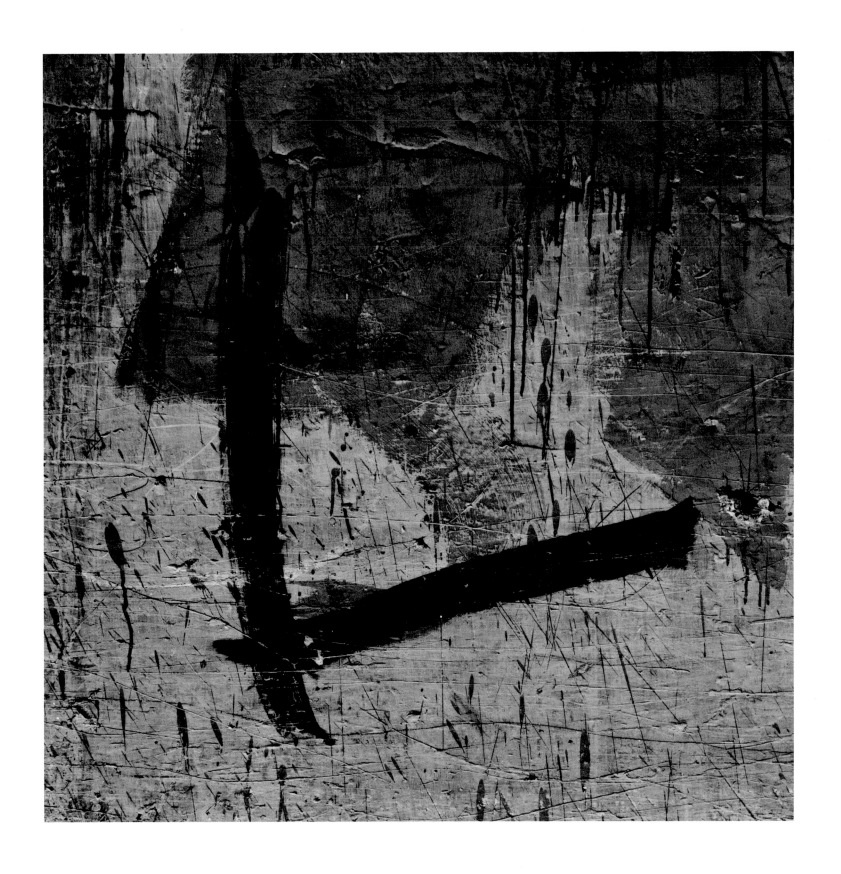

Lima 89 1975

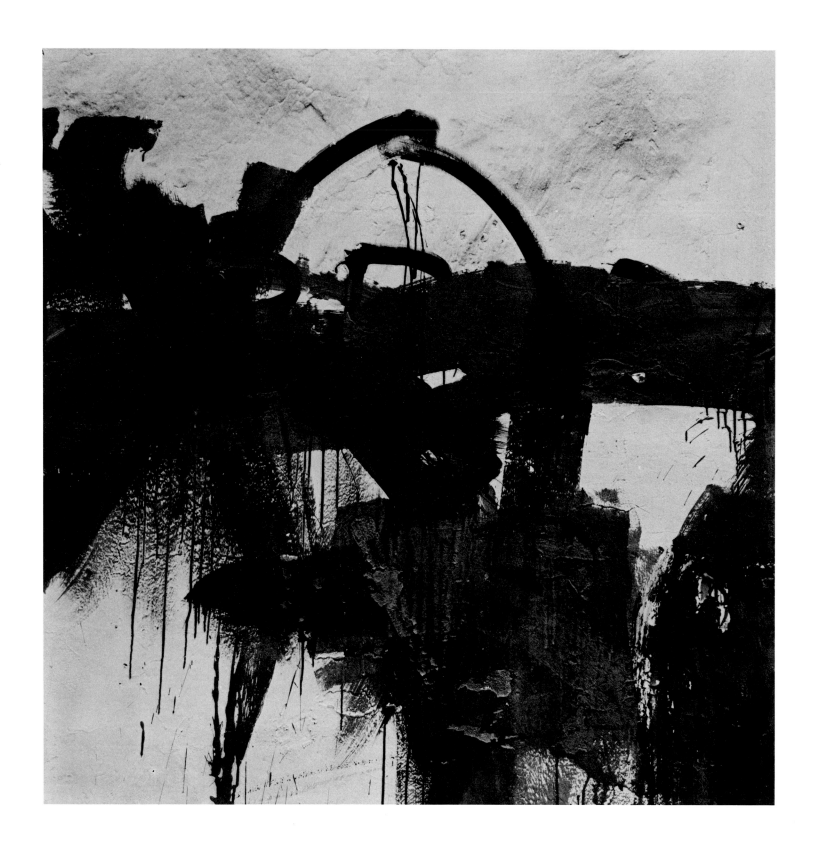

Lima 99 1975

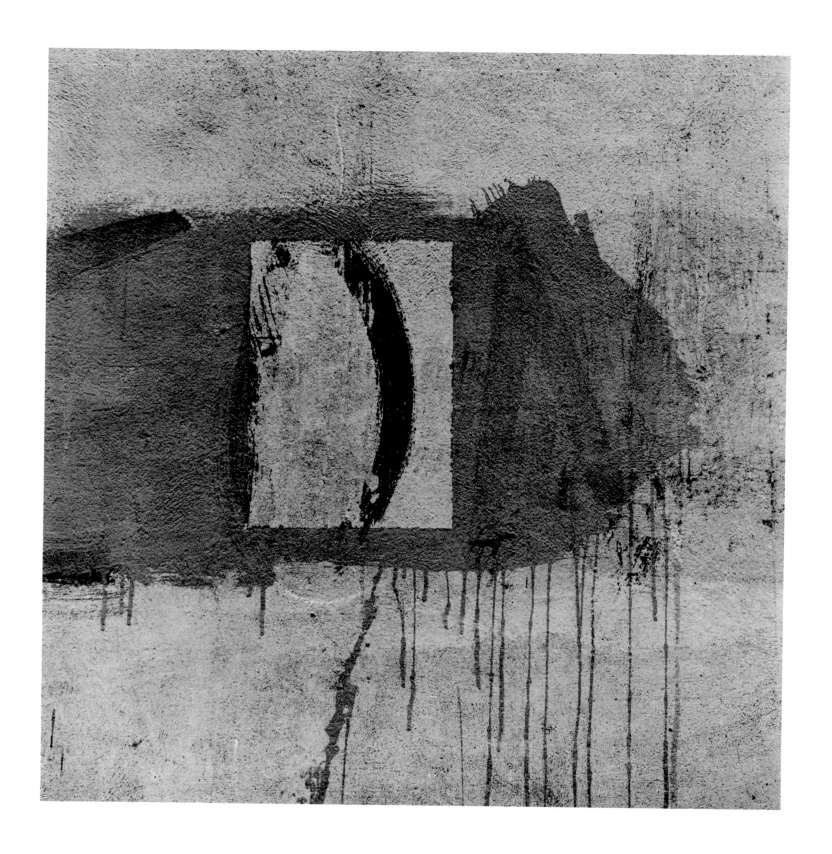

Lima 101 1975

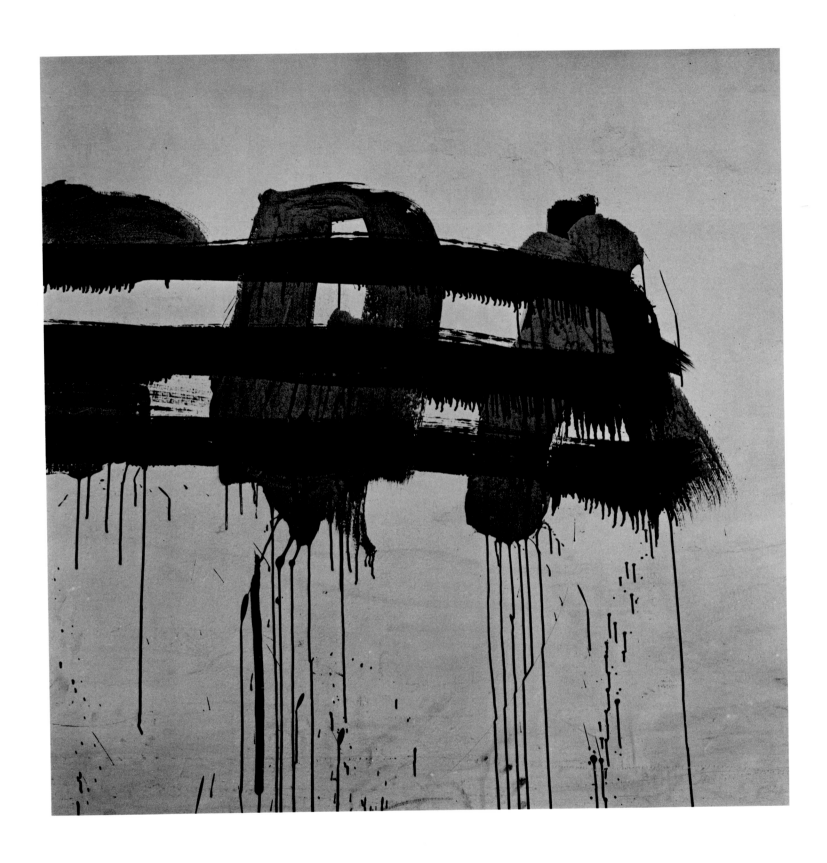

Lima 63 1975

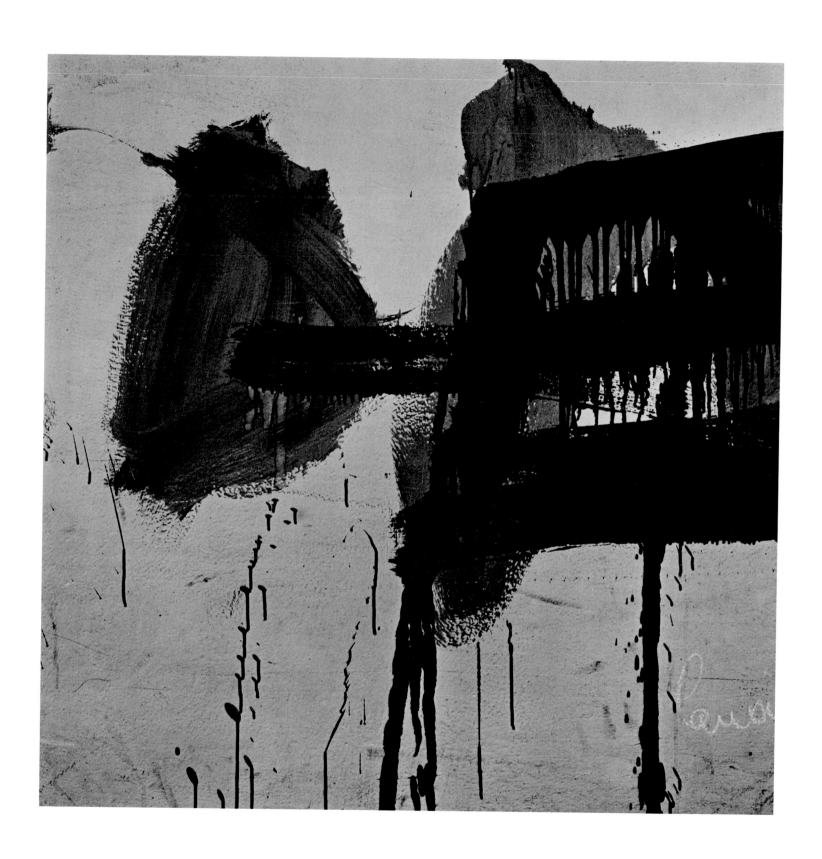

Lima 59 1975

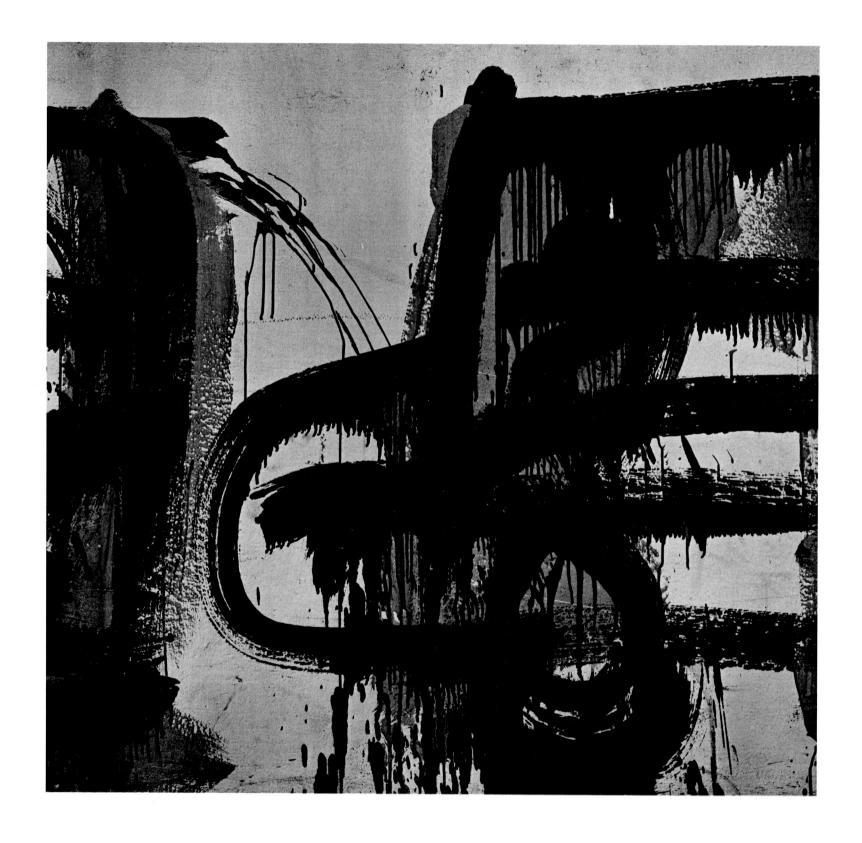

Lima 55 1975

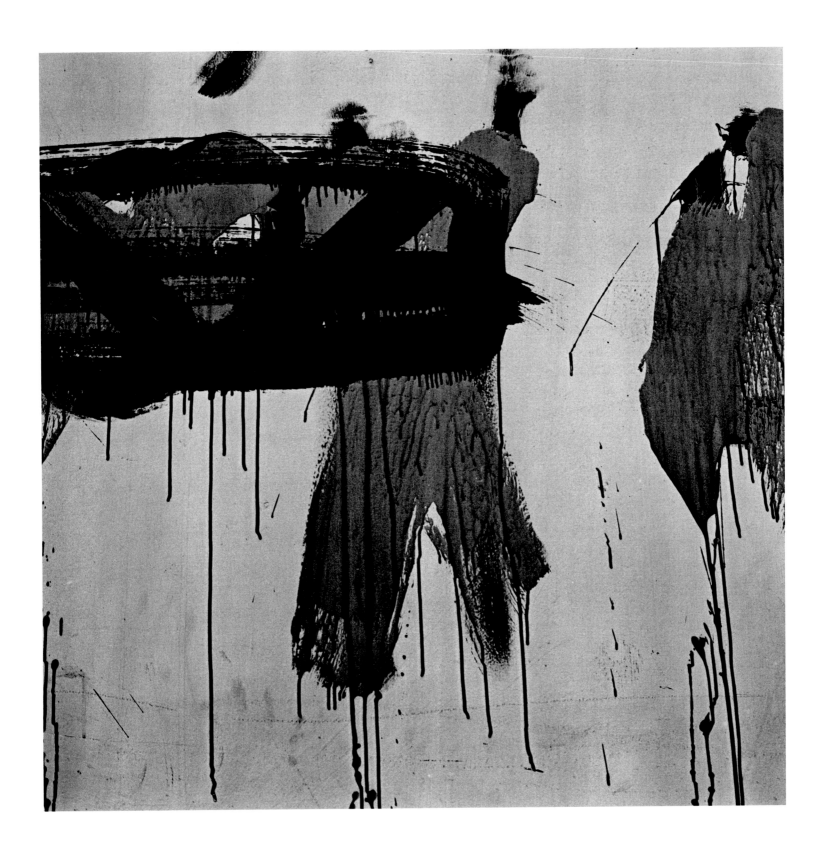

Lima 80 1975

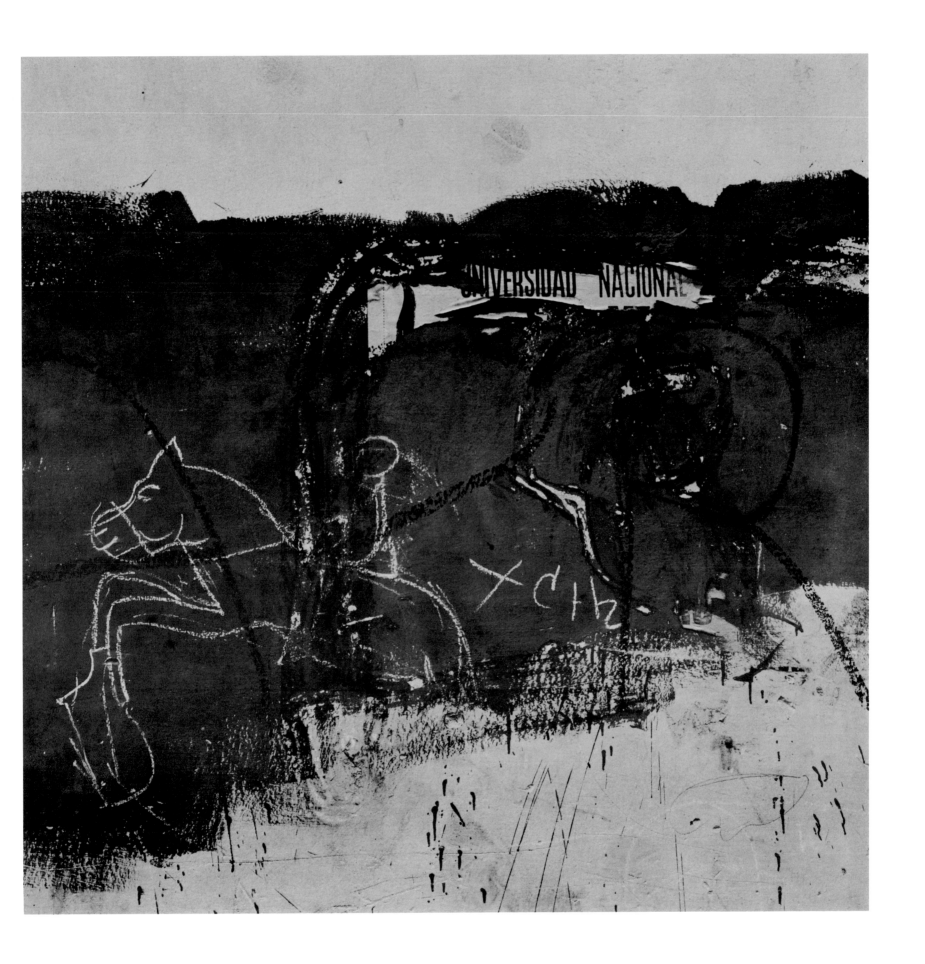

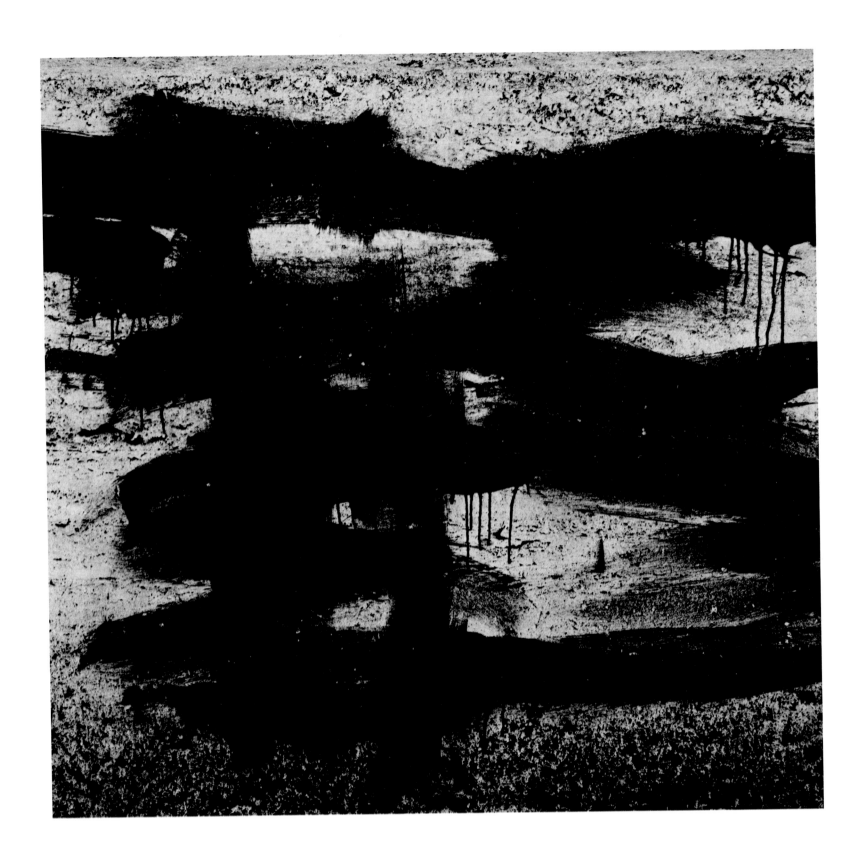

Rome 69 1973

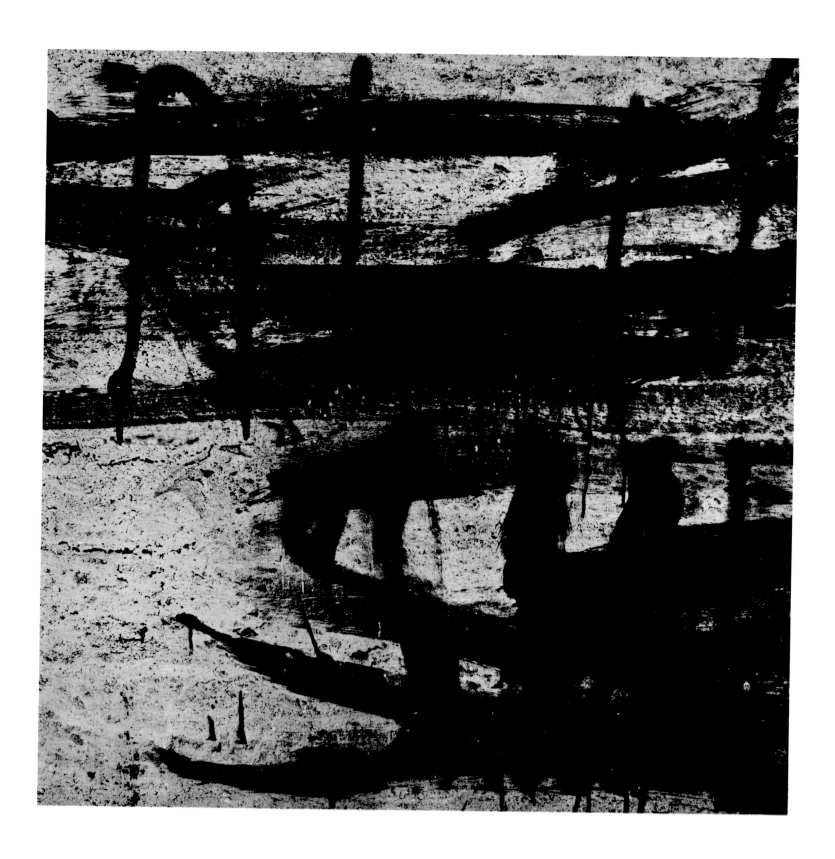

Rome 83 1973

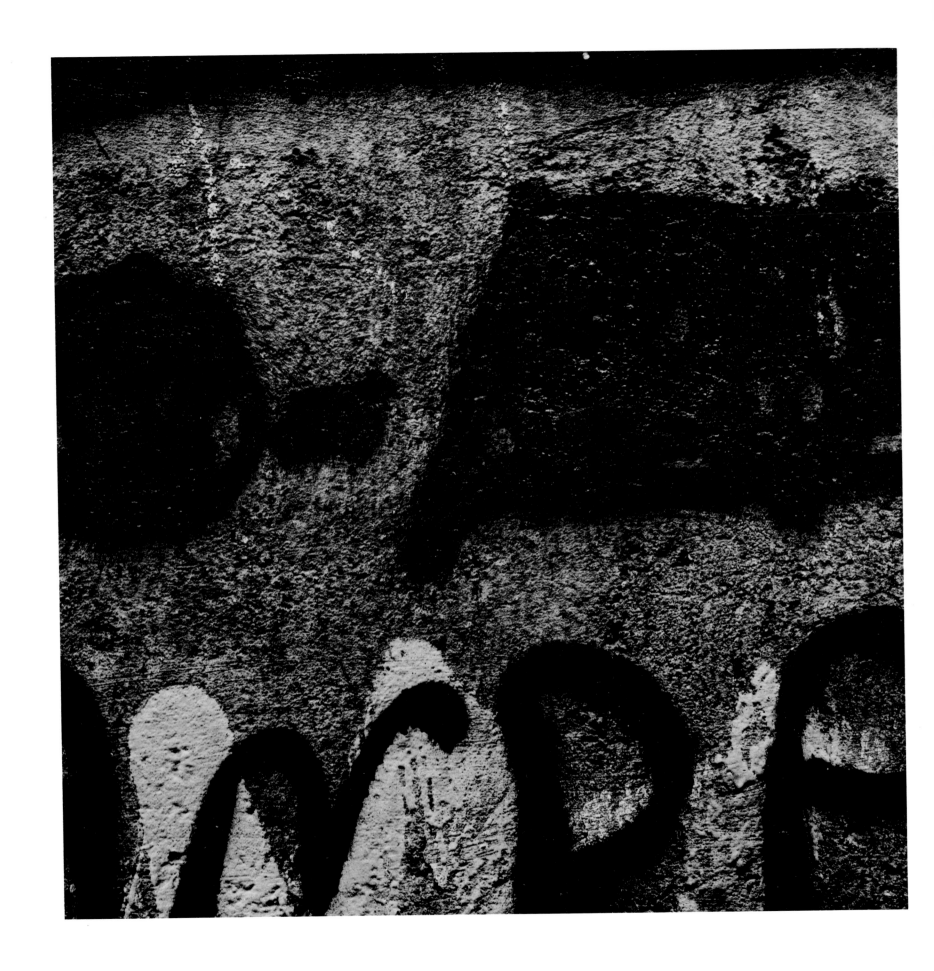

Rome 179 1973

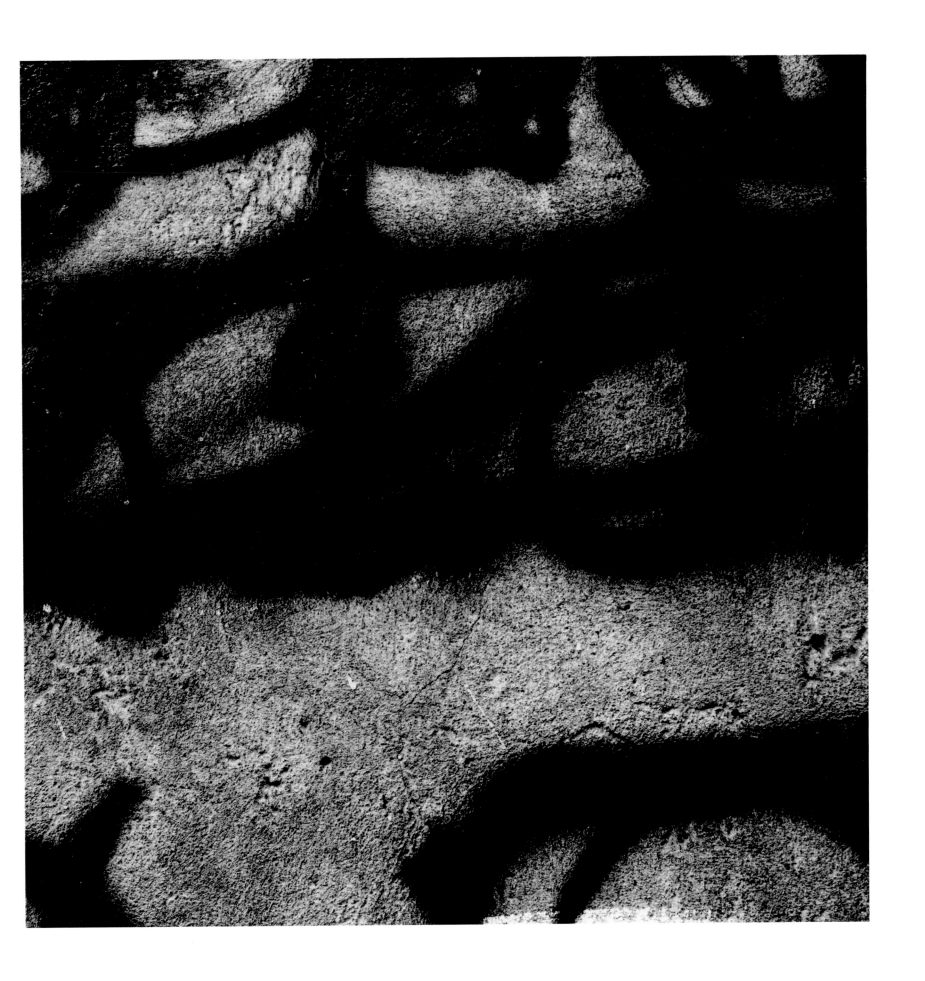

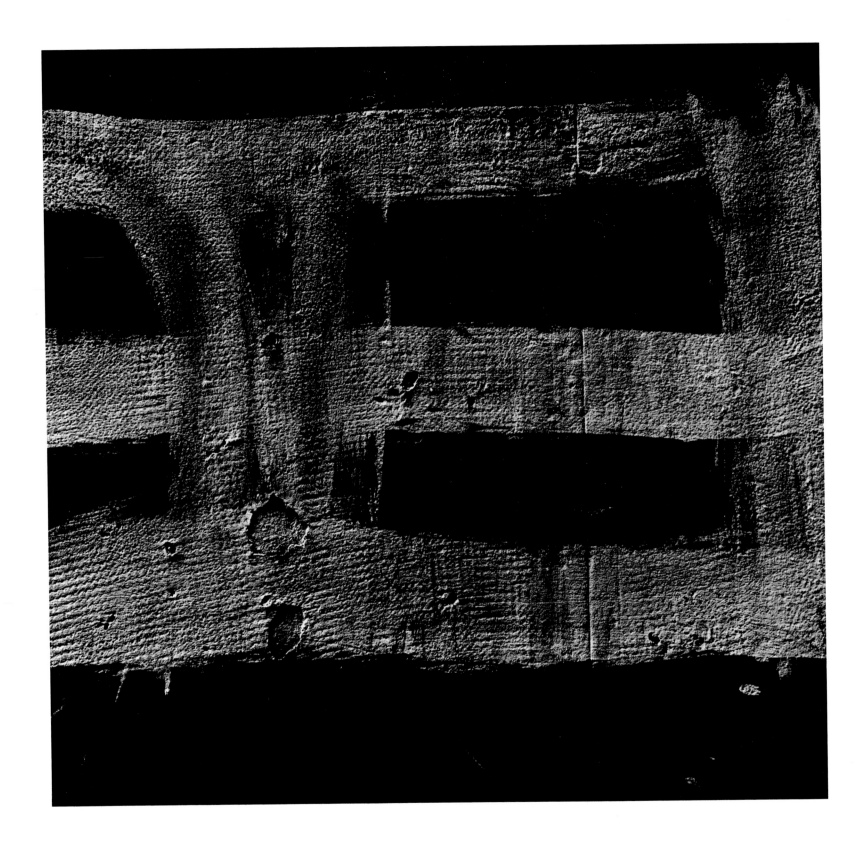

Rome 156 1973

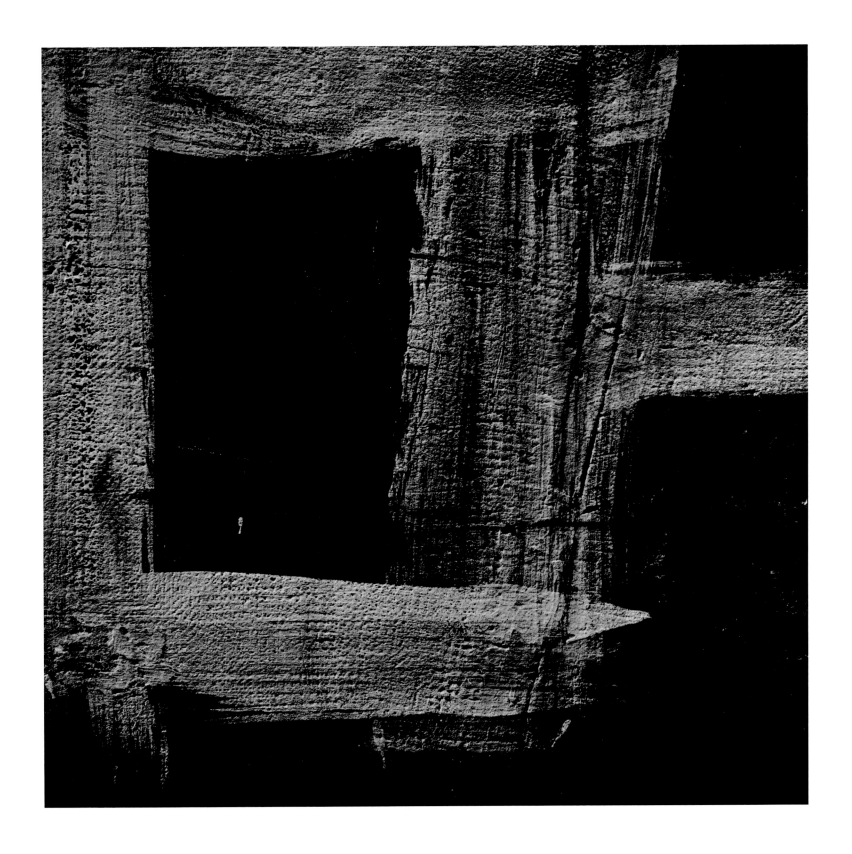

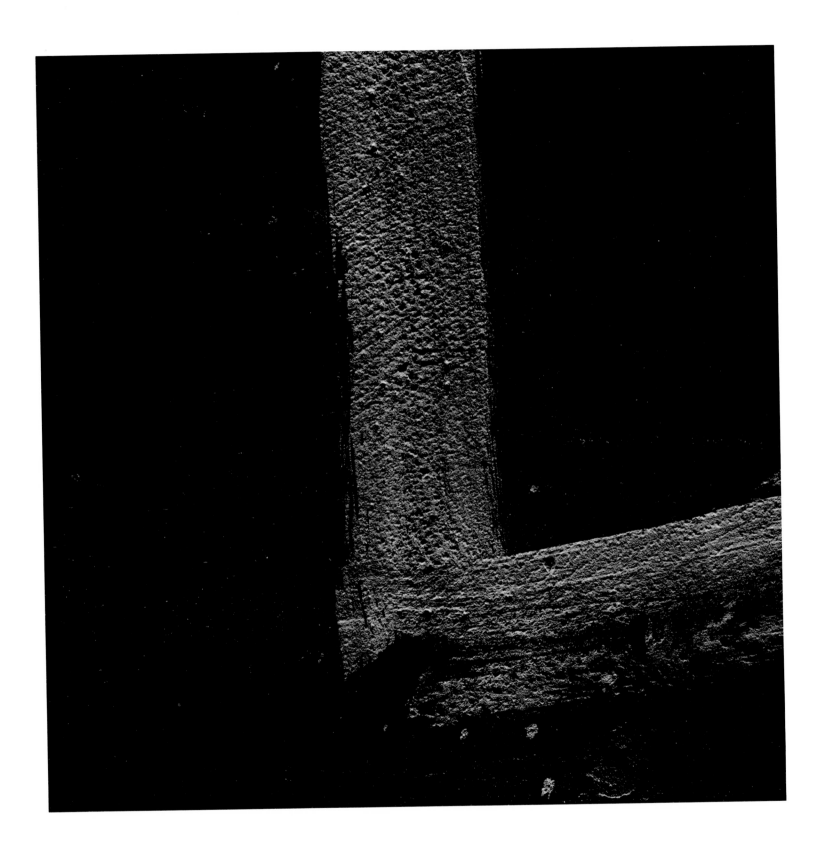

Rome 2 1973

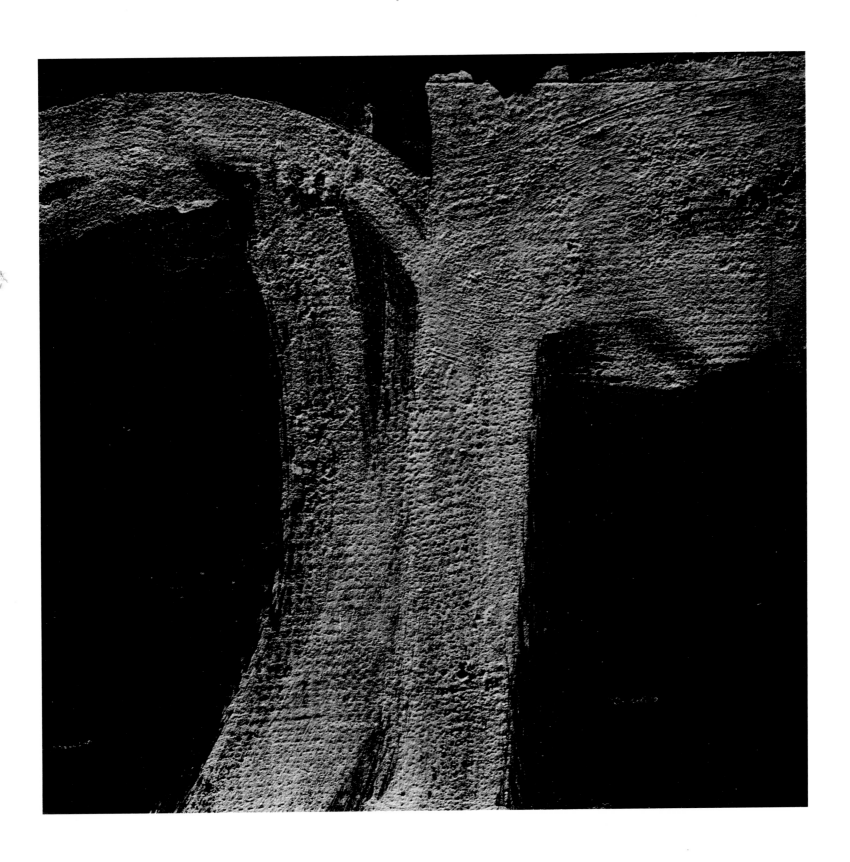

Rome 150 1973

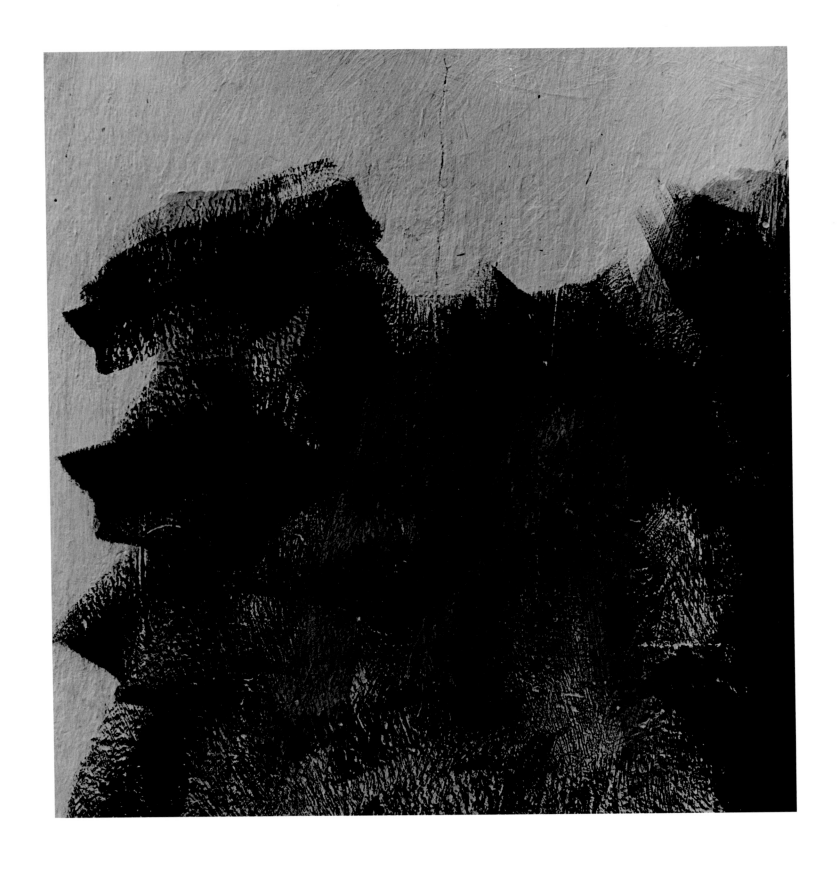

Jalapa 31 1973

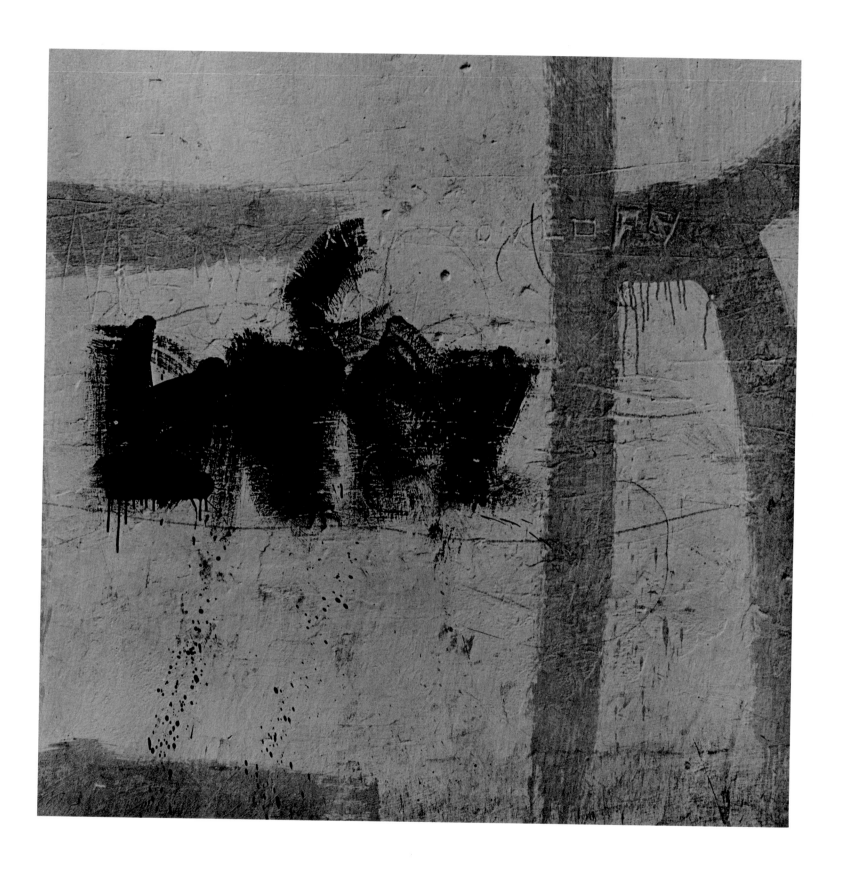

Jalapa 43 1973

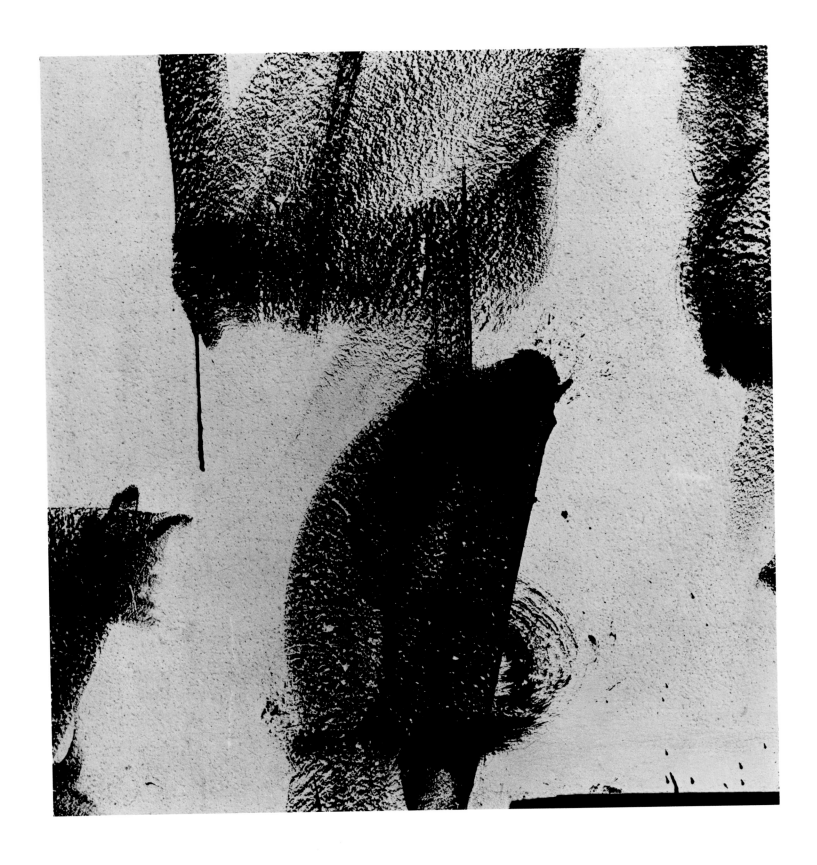

Jalapa 10 1973

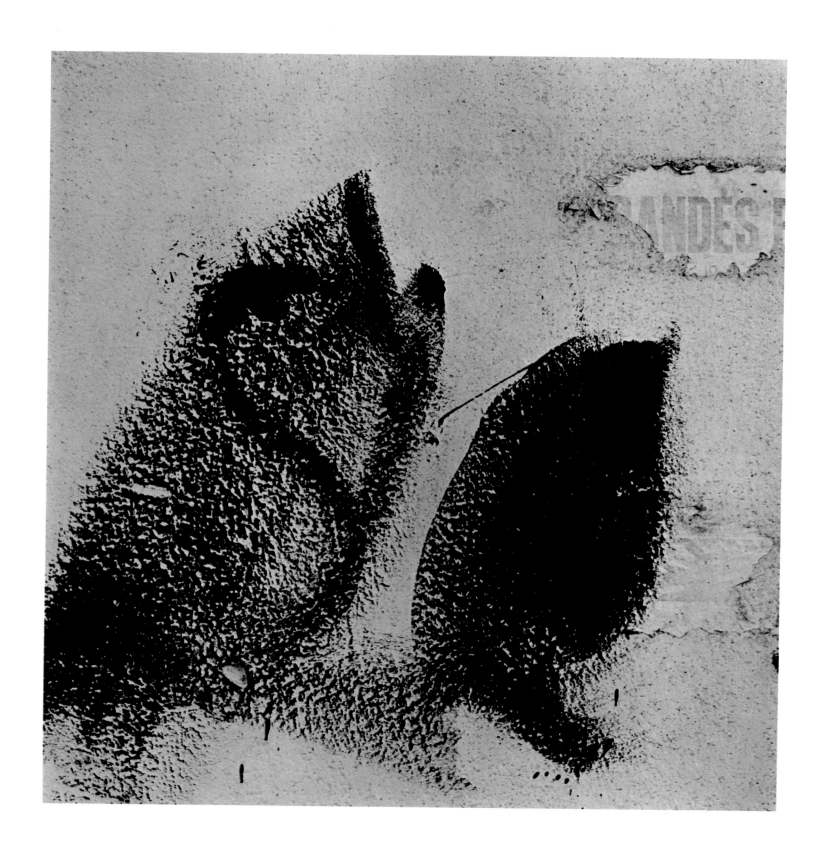

Jalapa 11 1973

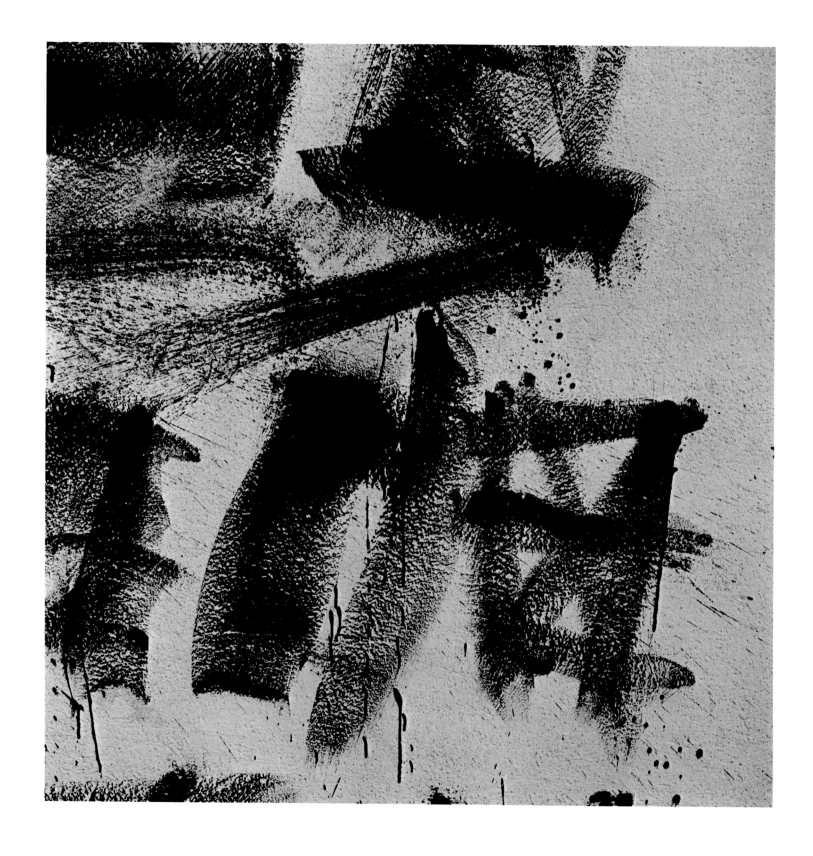

Jalapa 27 1973

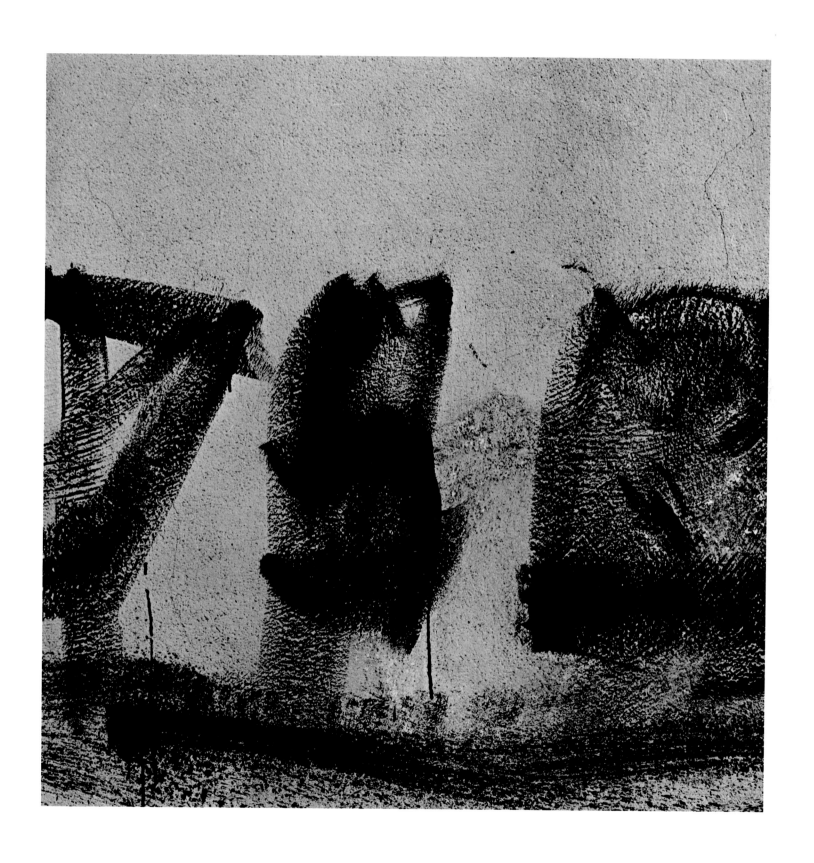

Jalapa 26 1973

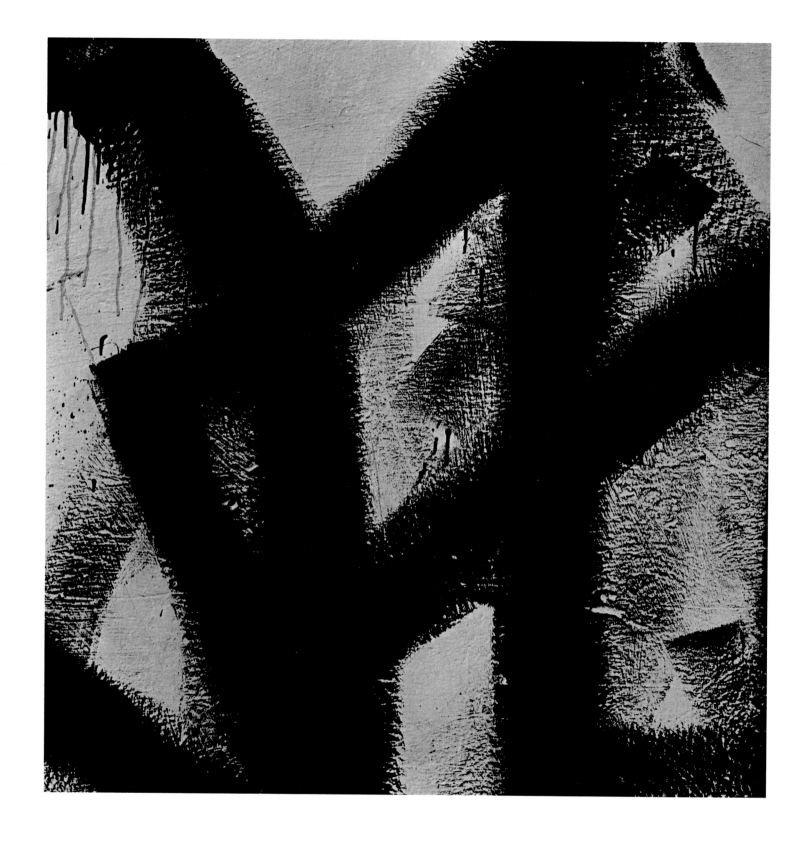

Jalapa 35 1973

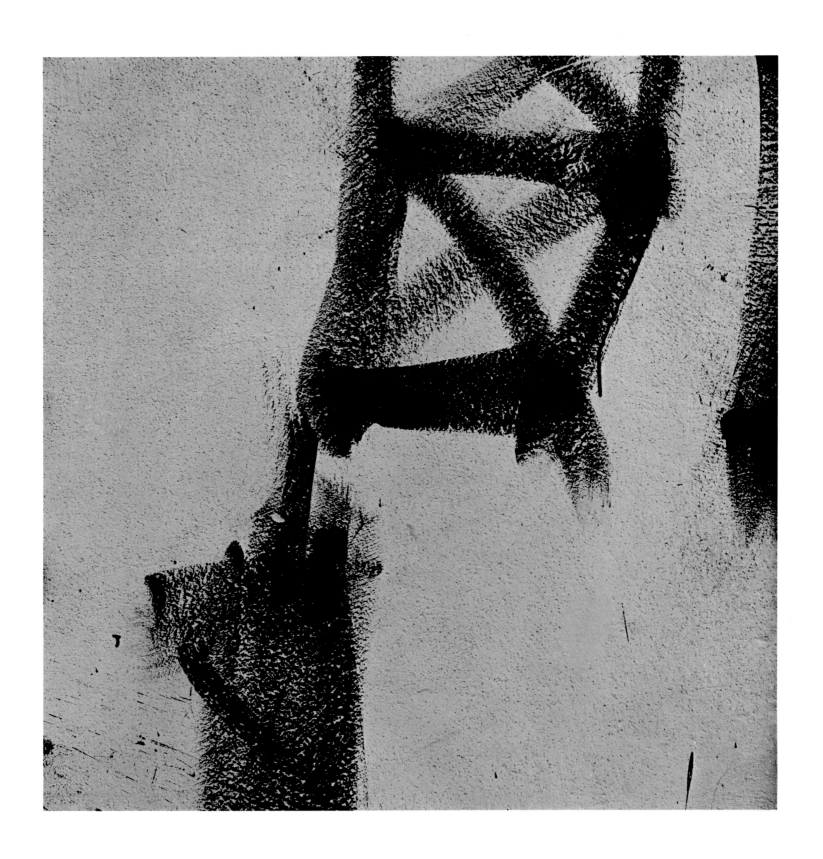

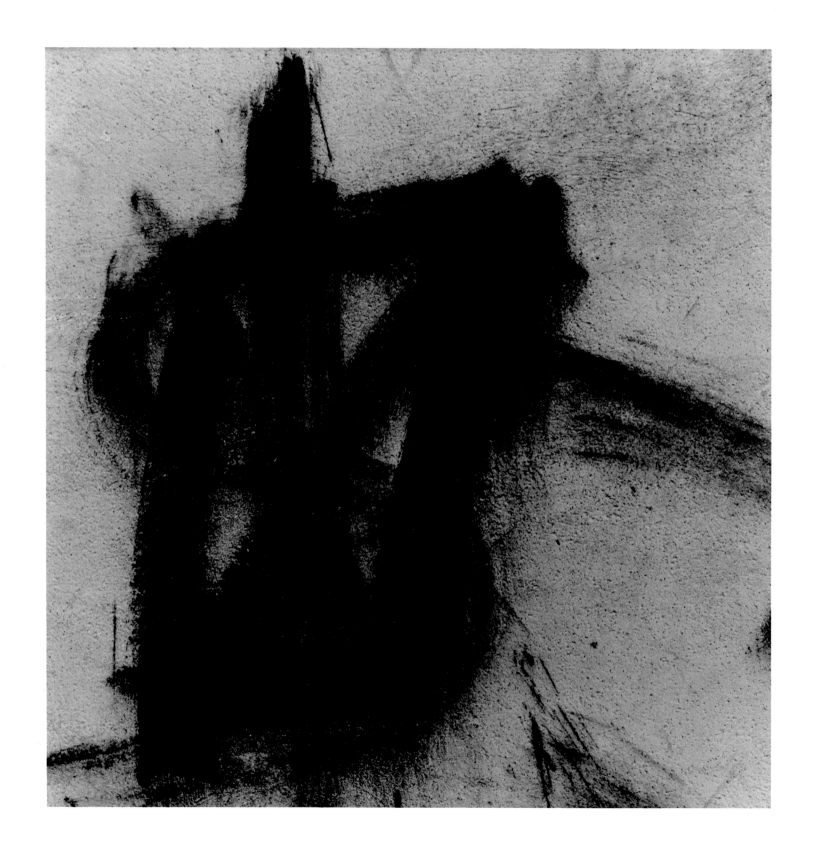

Jalapa 42 1974

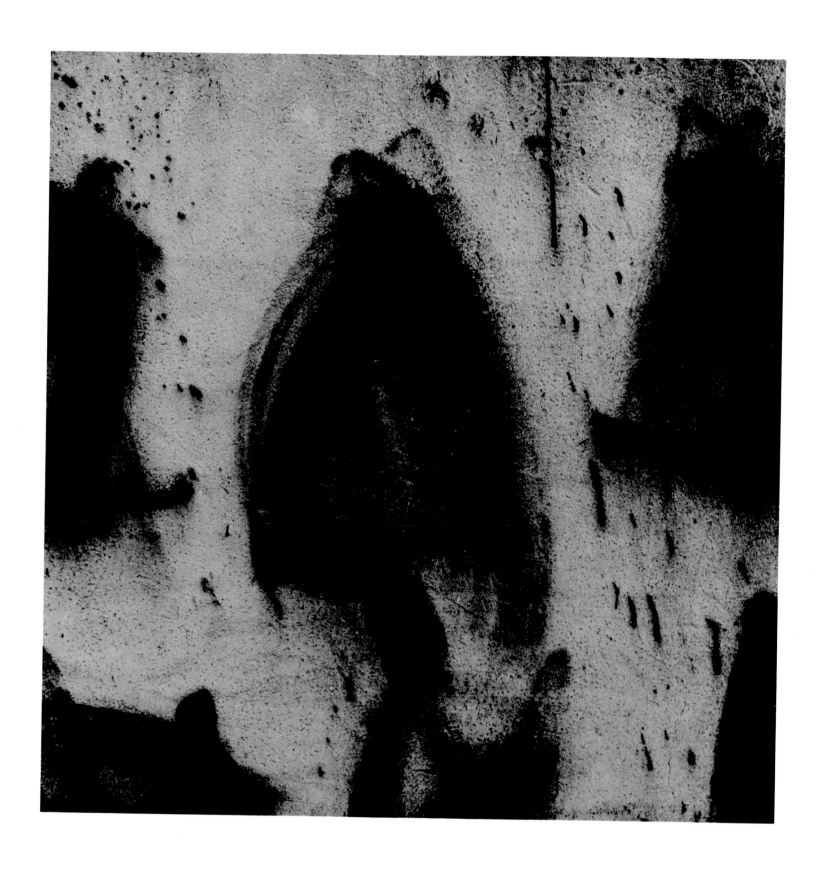

Jalapa 43 1974

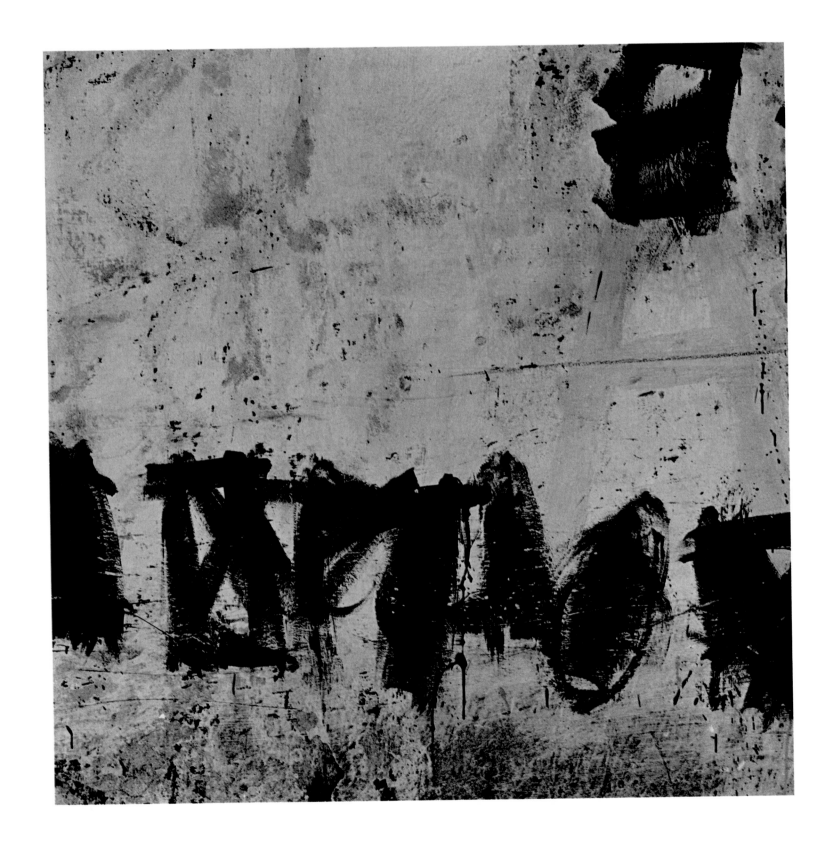

Jalapa 6 1973

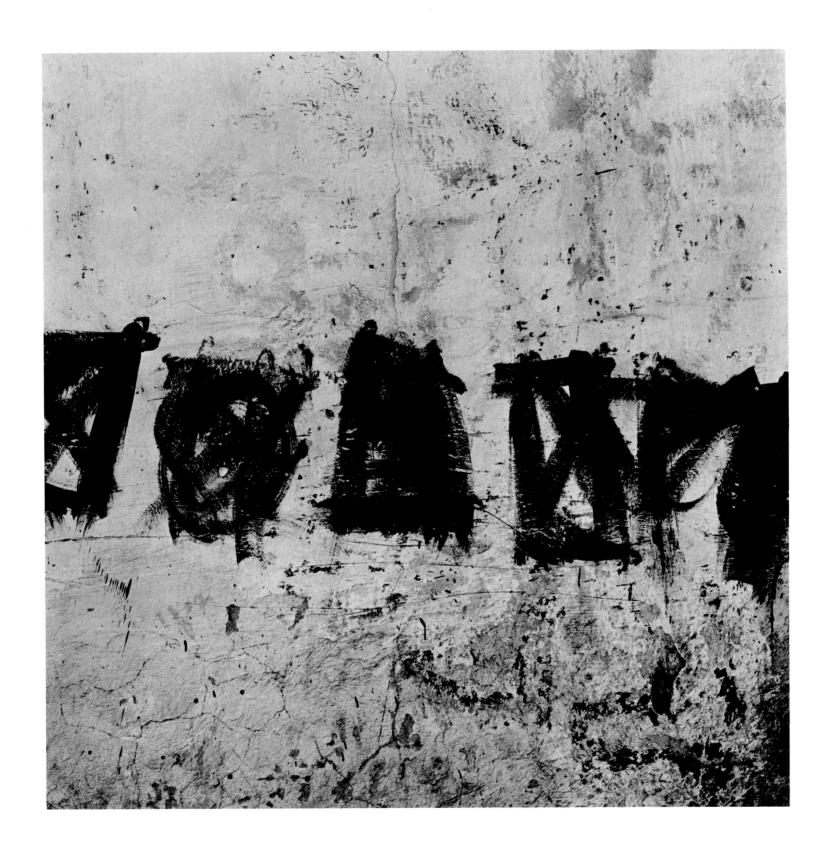

Jalapa 7 1973

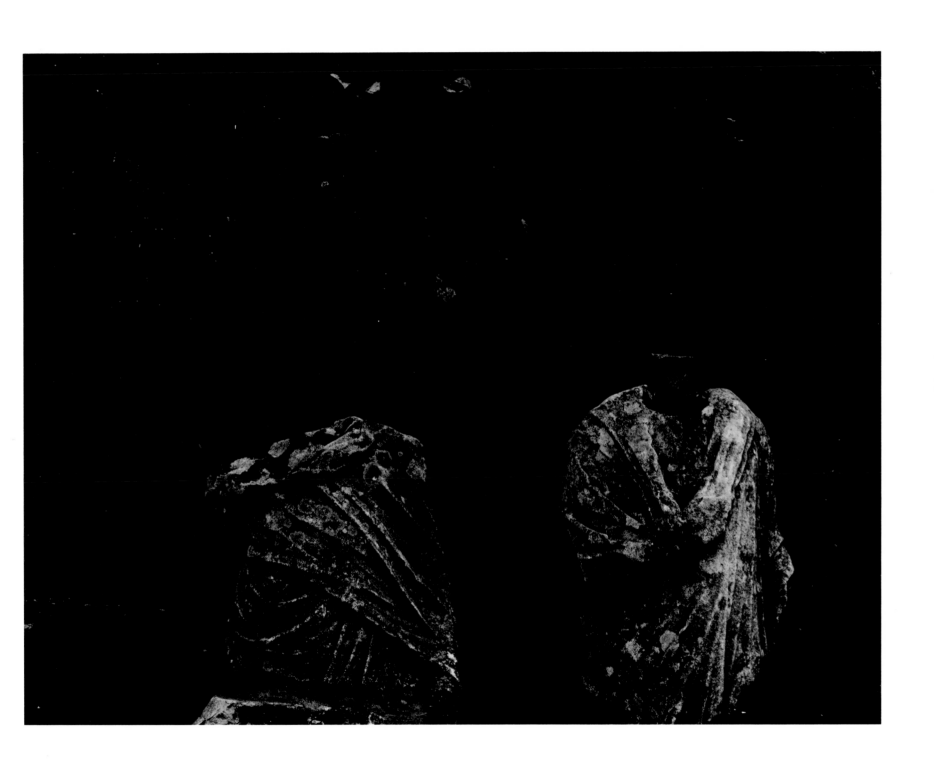

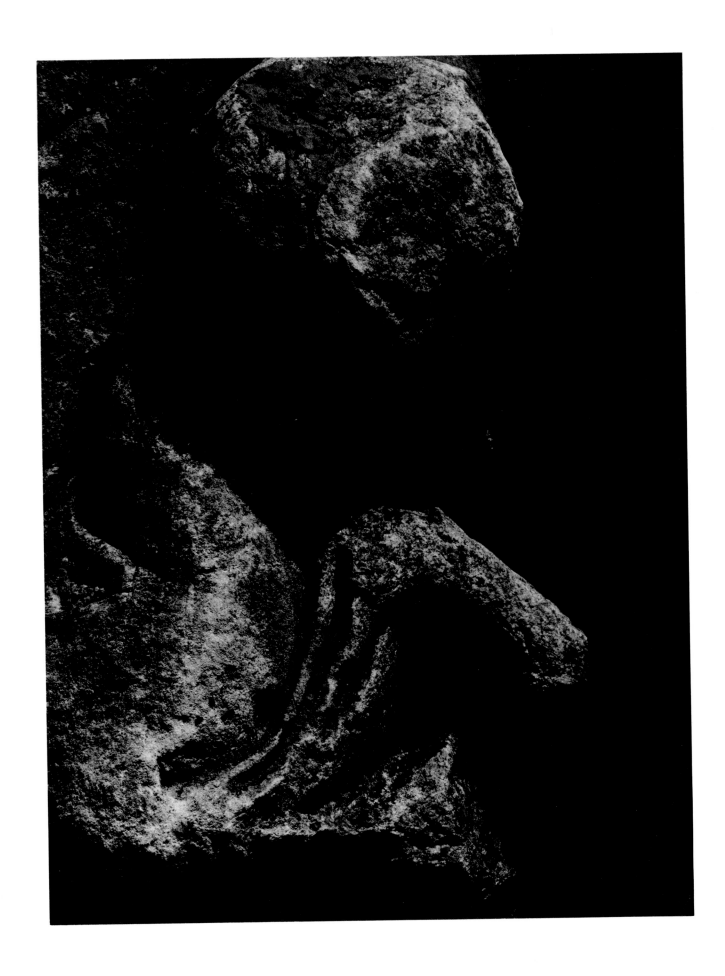

Rome: Arch of Constantine 3 1967

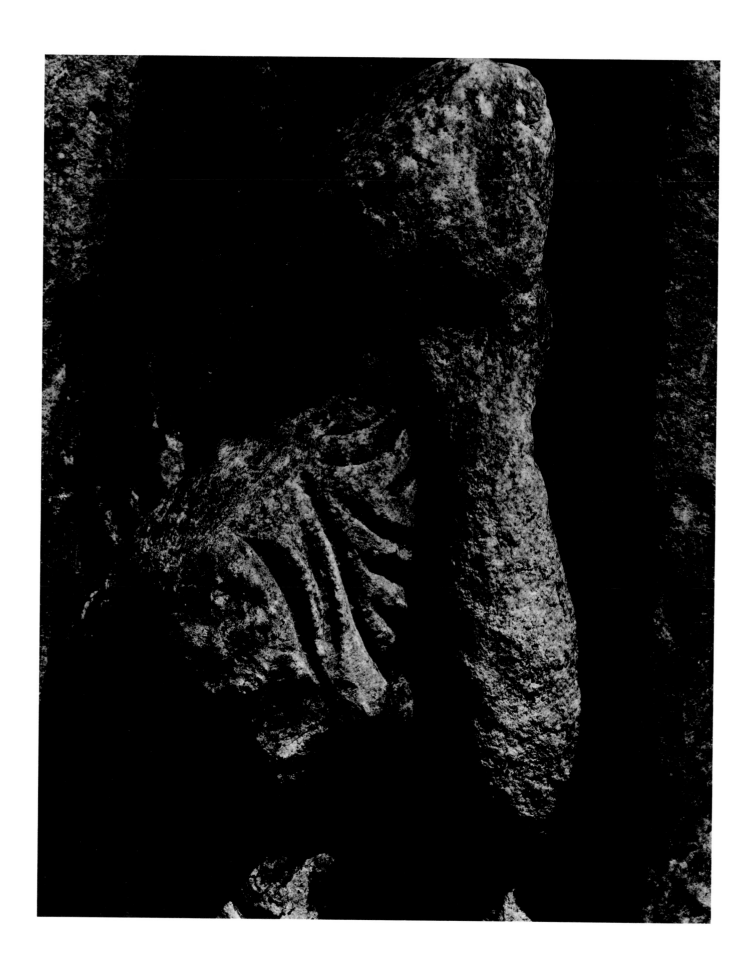

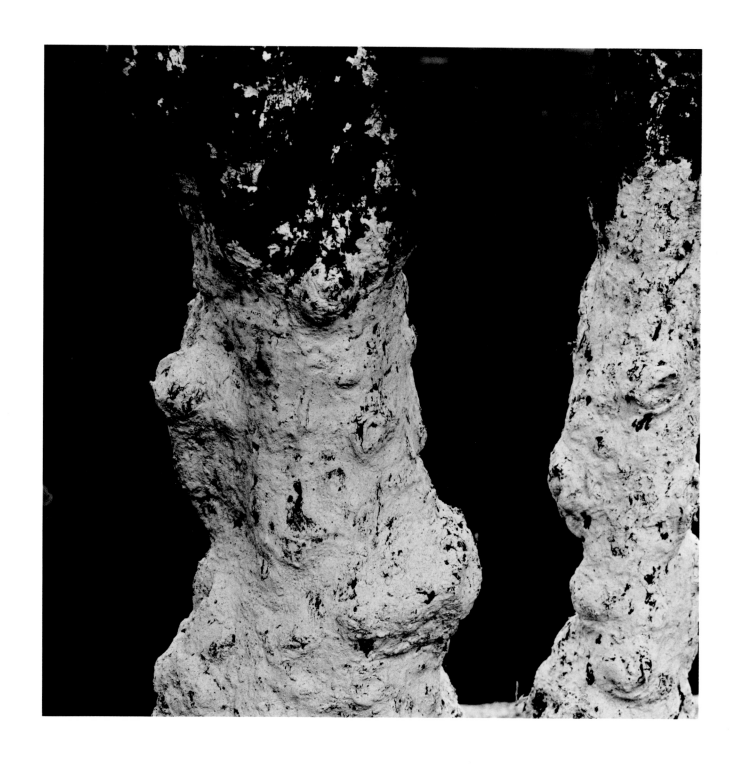

Vera Cruz 288 1973

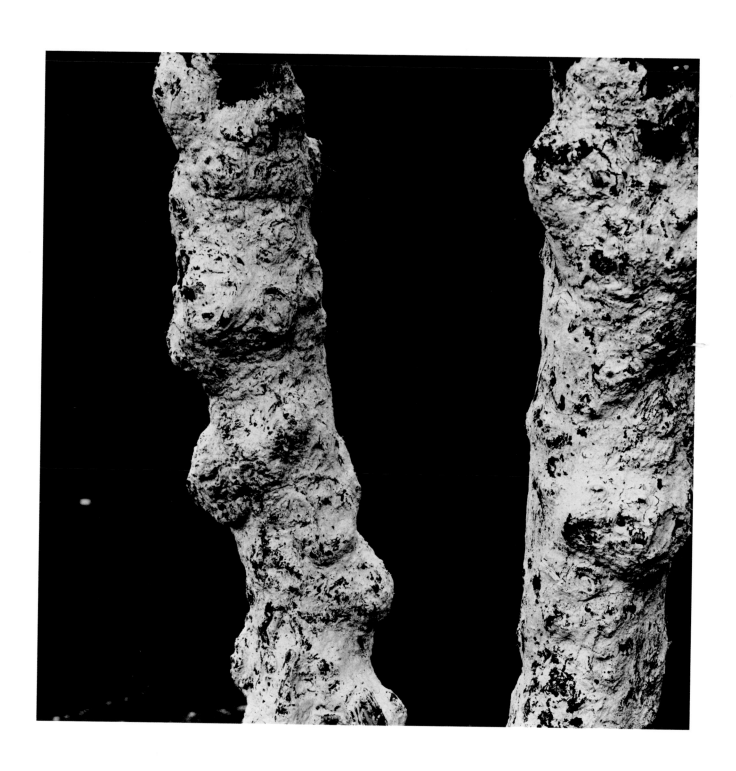

Vera Cruz 292 1973

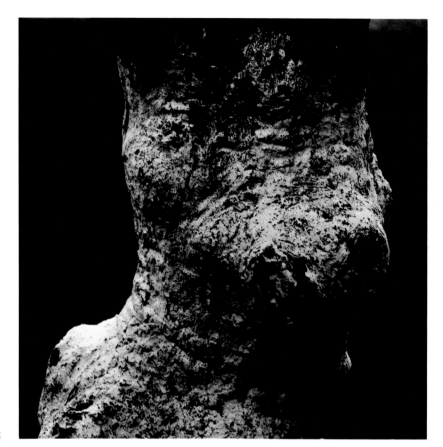

278

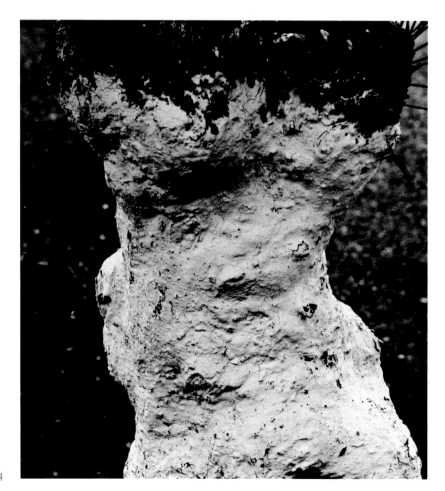

274

Vera Cruz 1973

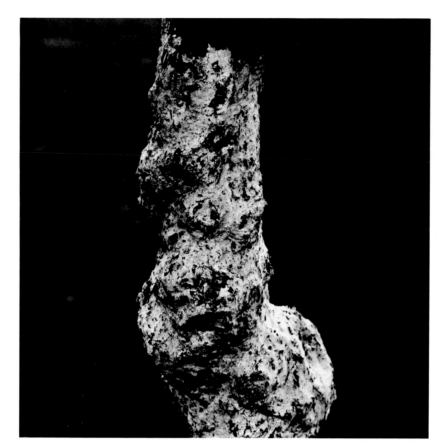

272

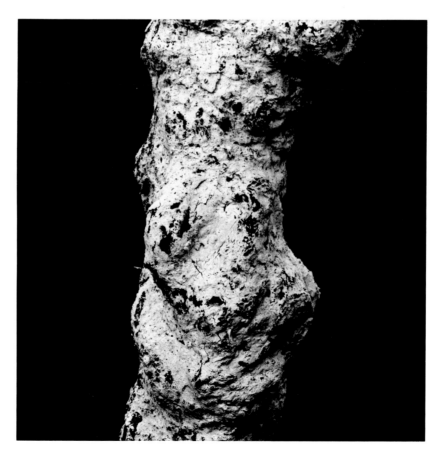

289

Vera Cruz 1973

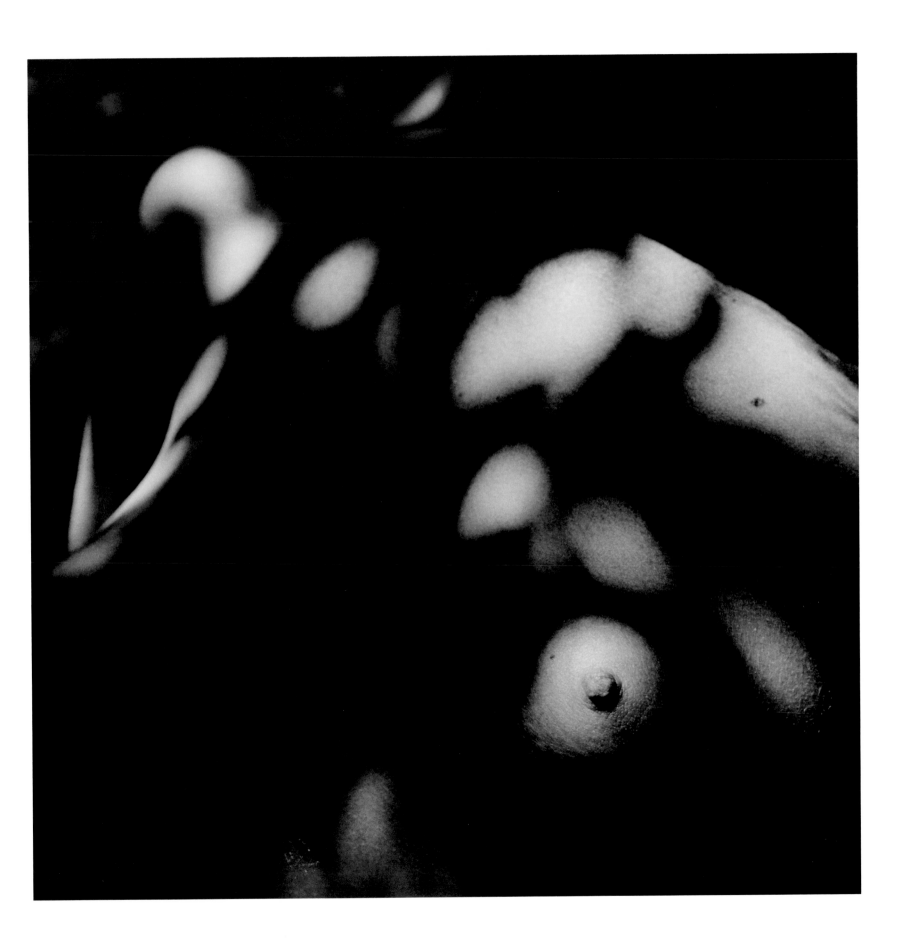

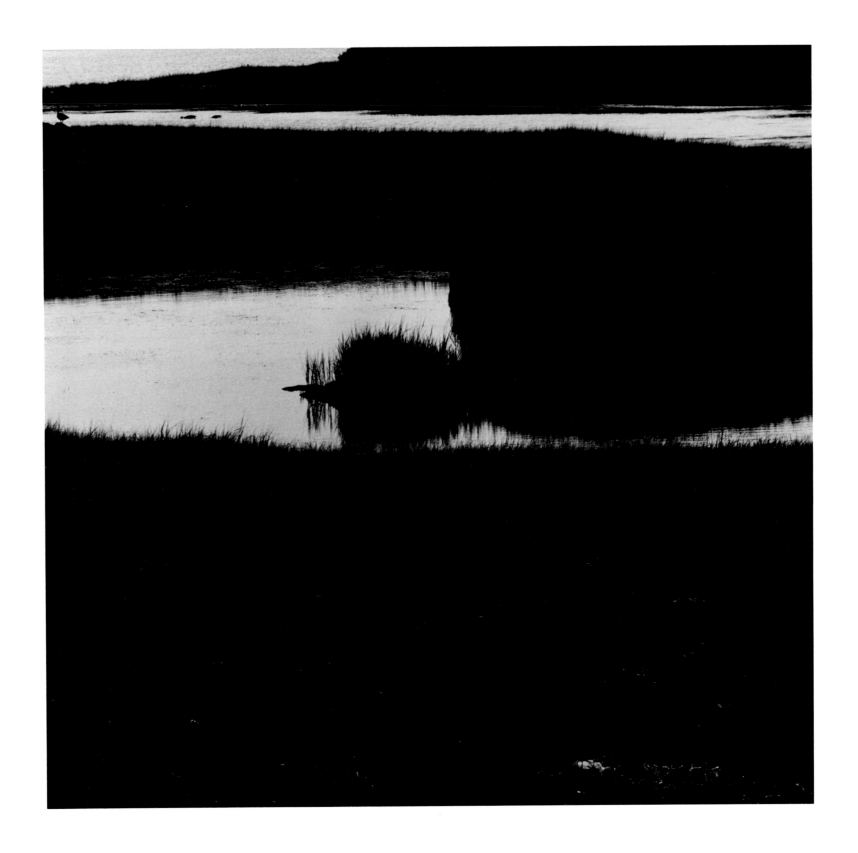

Chilmark 28 1972

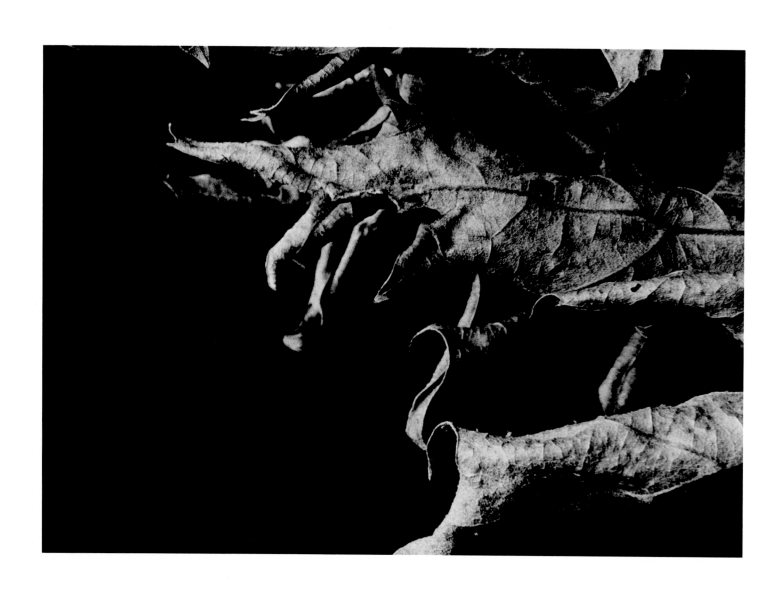

Martha's Vineyard F12 1969

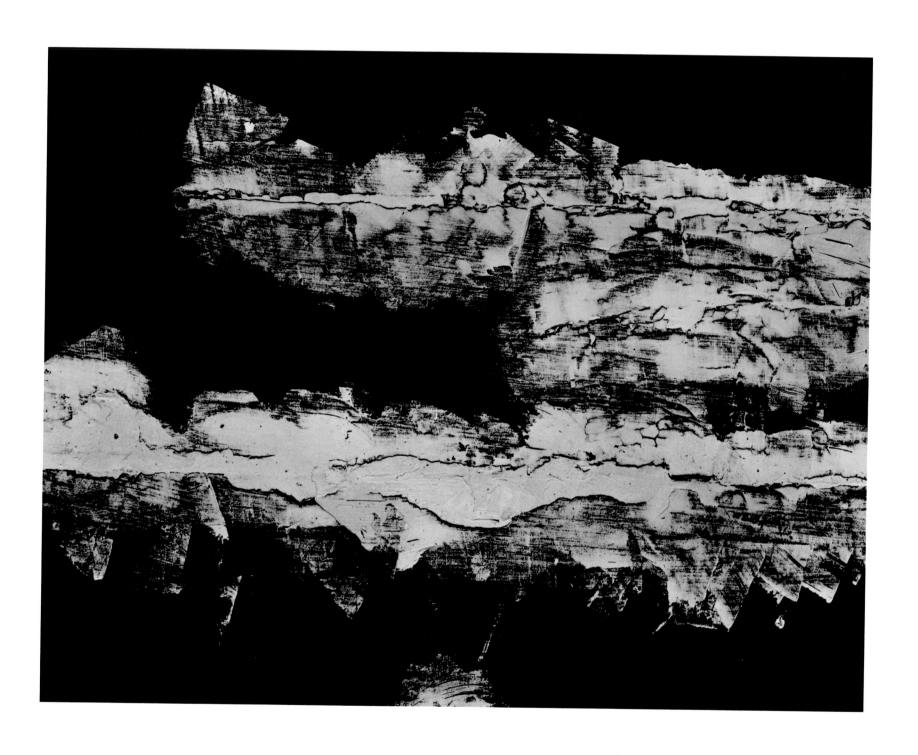

Rome 66 1967

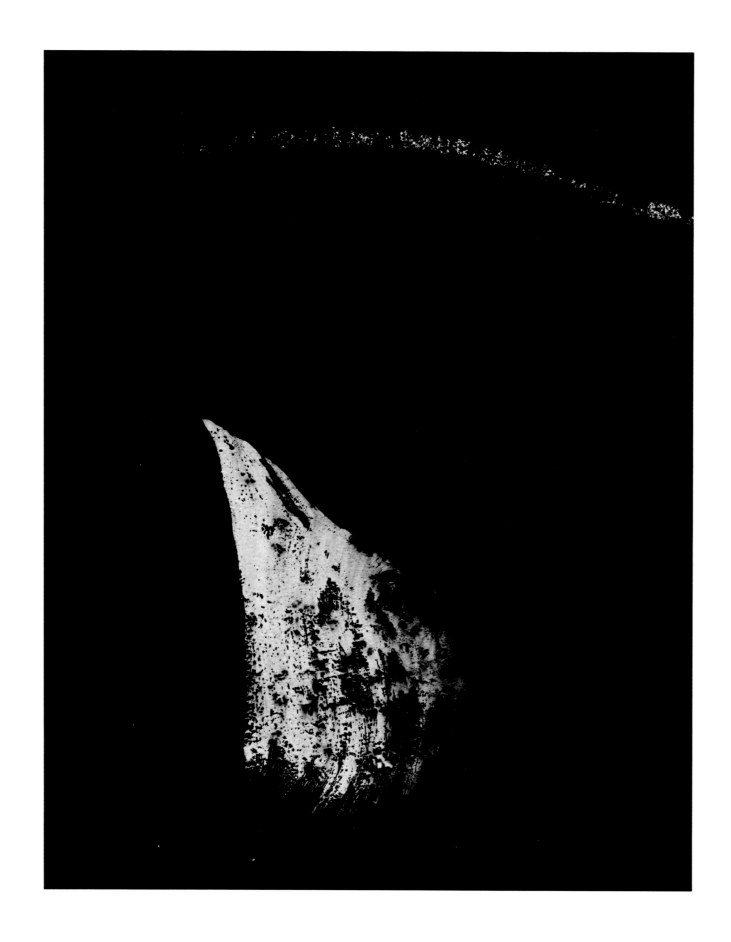

Rome 25 1967

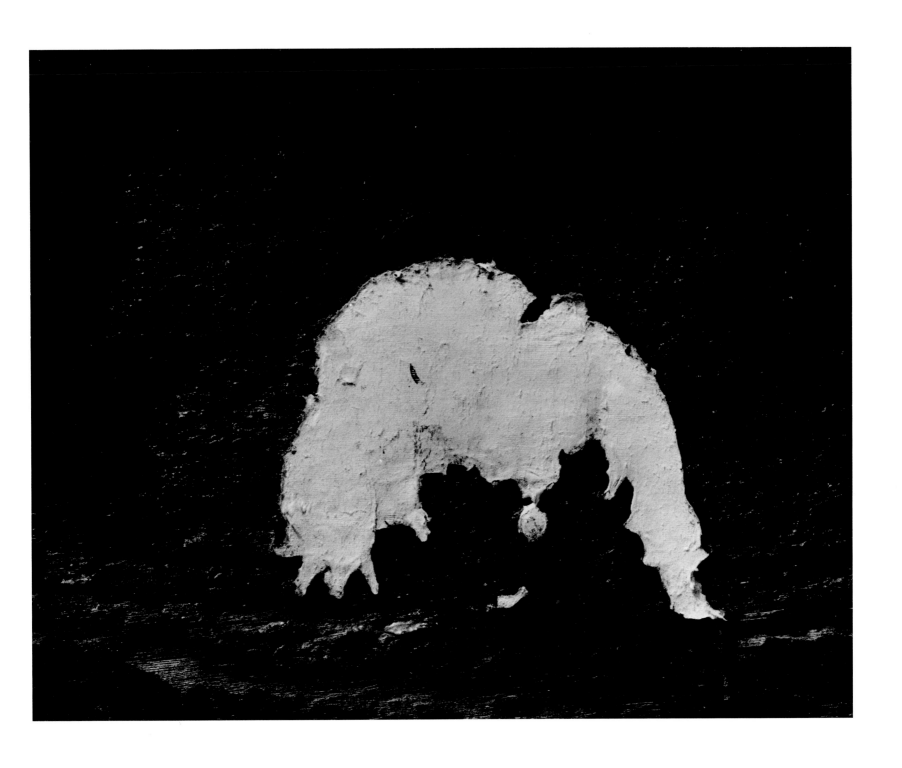

Rome 63 1967

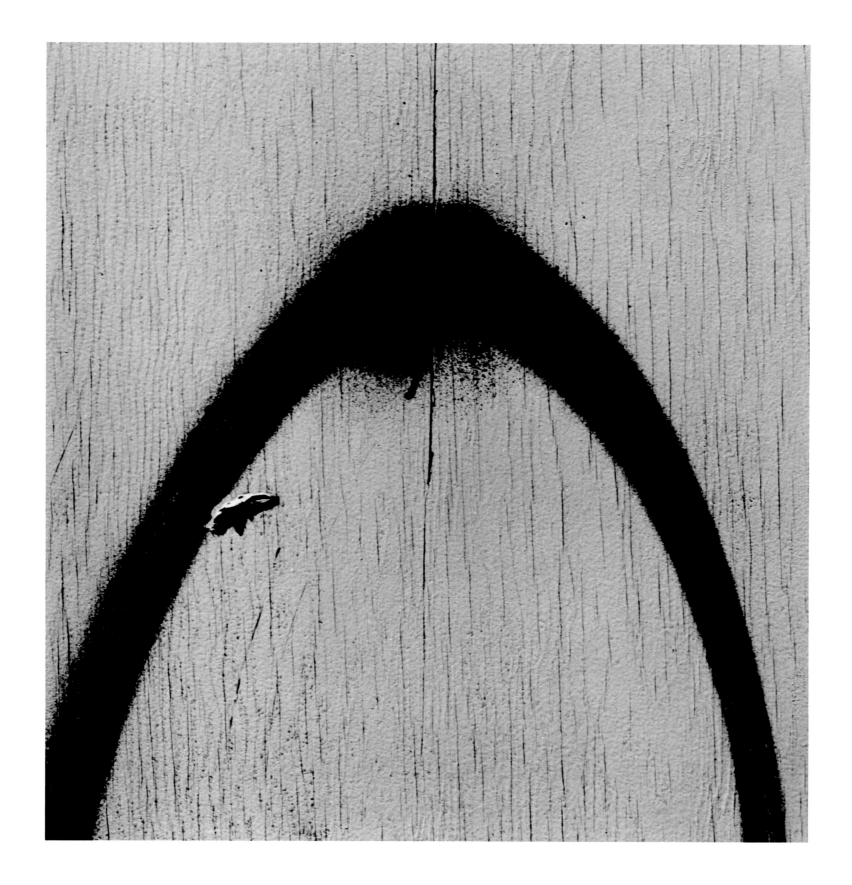

Providence 47 1972

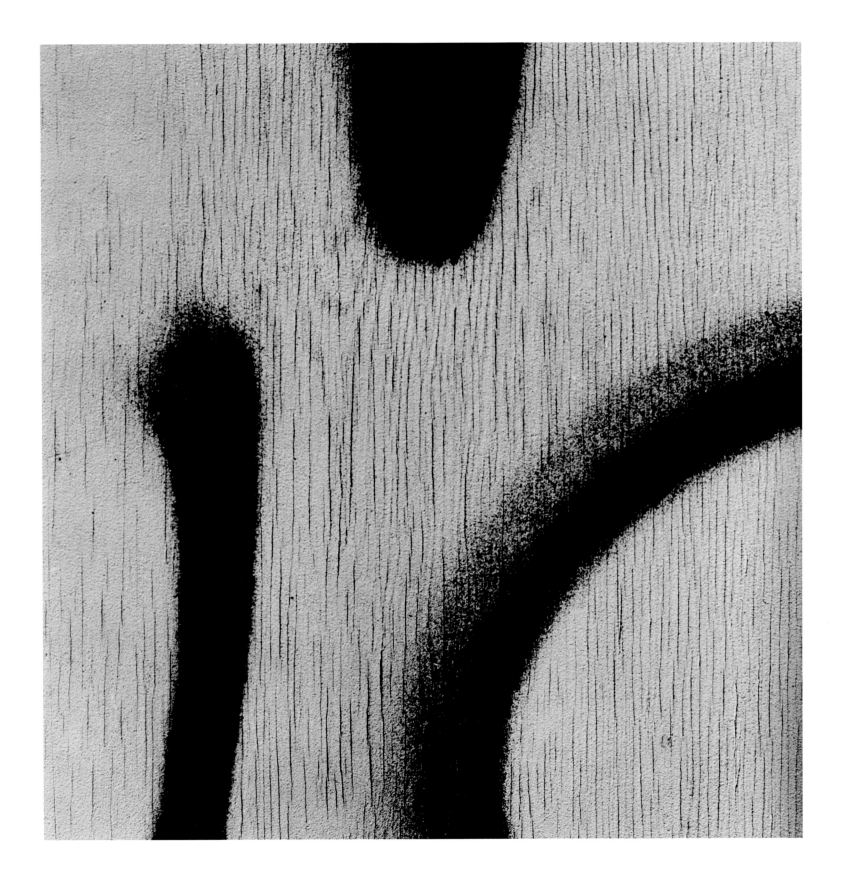

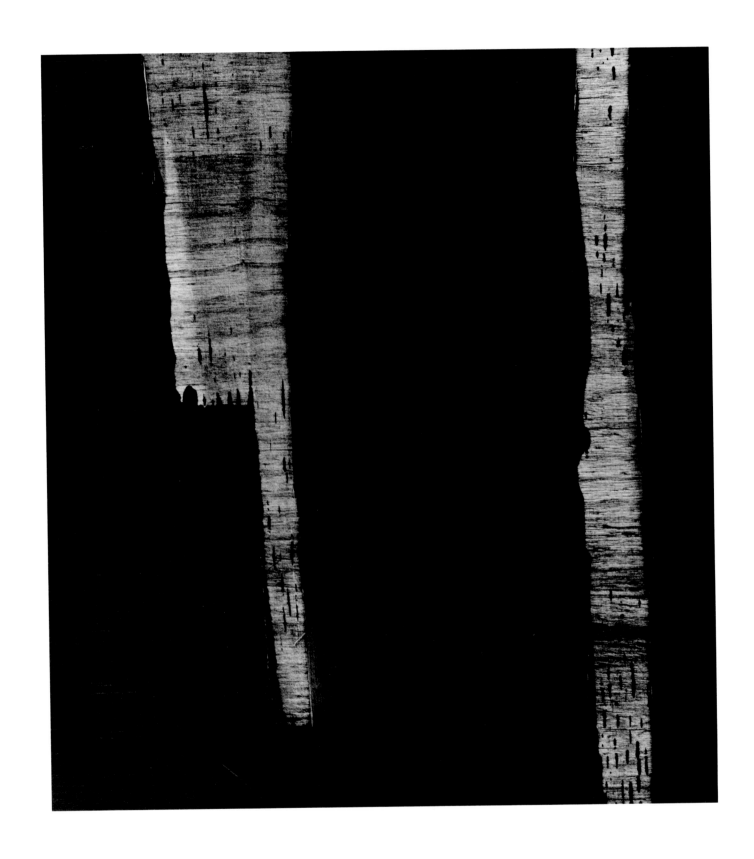

Woonsocket 9 1972

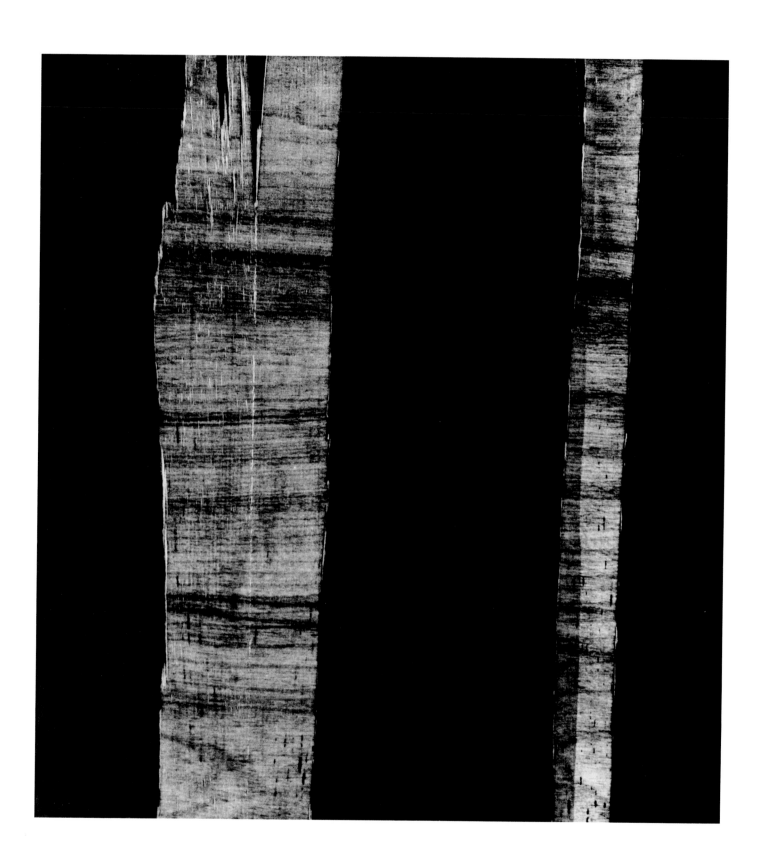

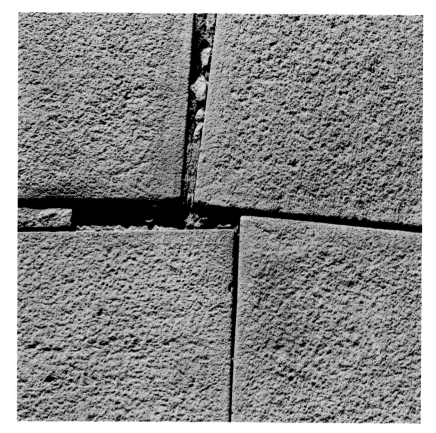

II

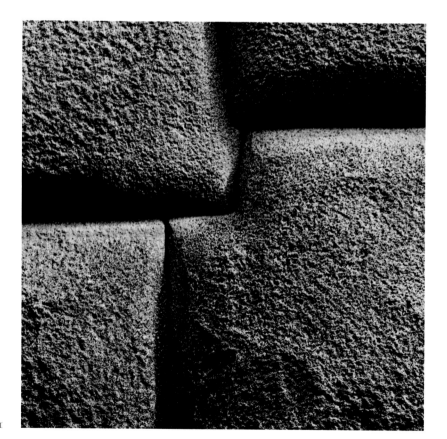

91

Cusco 1975

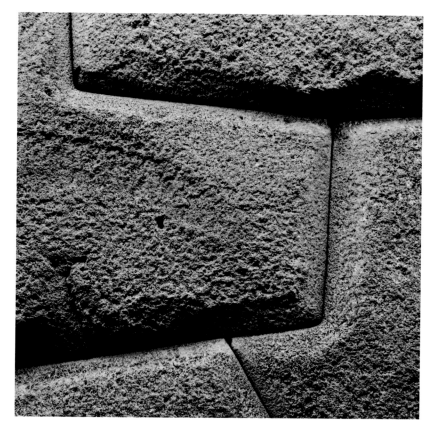

14

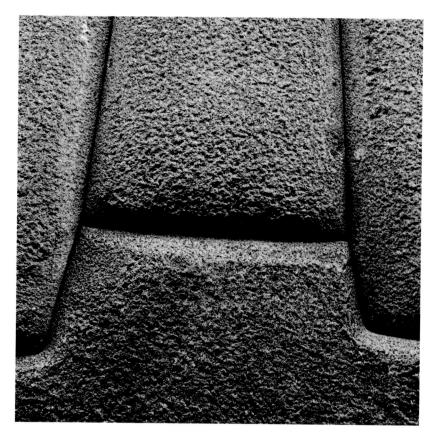

61

Villahermosa (Olmec) 5 1973

Jalapa (Olmec) 4 1973

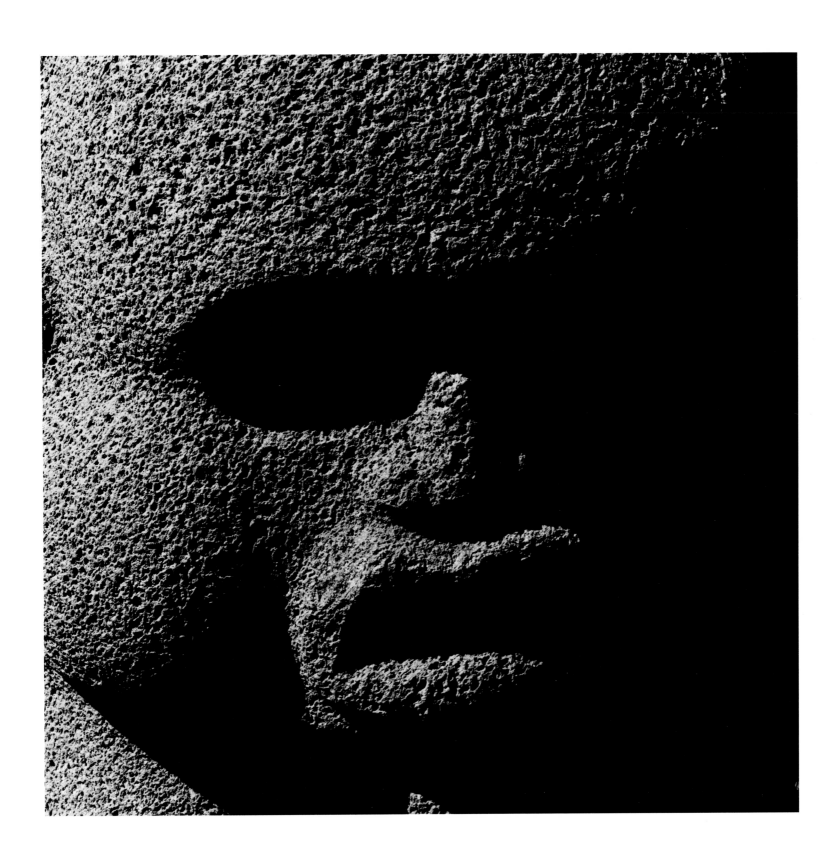

Villahermosa (Olmec) 13 1973

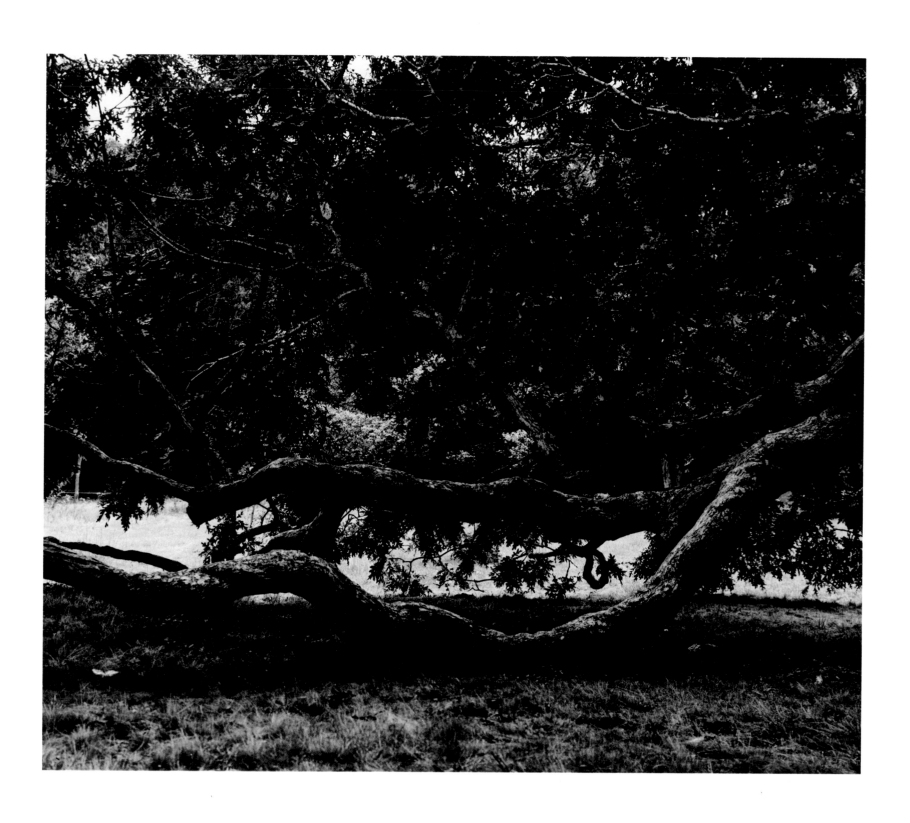

Martha's Vineyard (The Tree) 2 1973

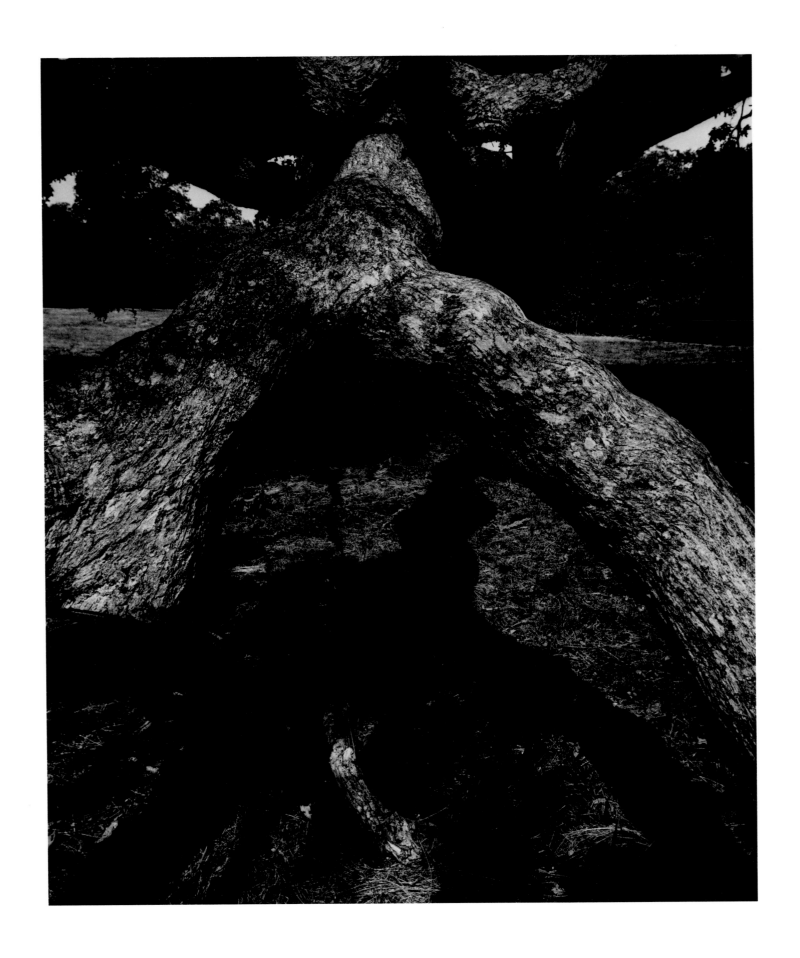

Martha's Vineyard (The Tree) 62 1973

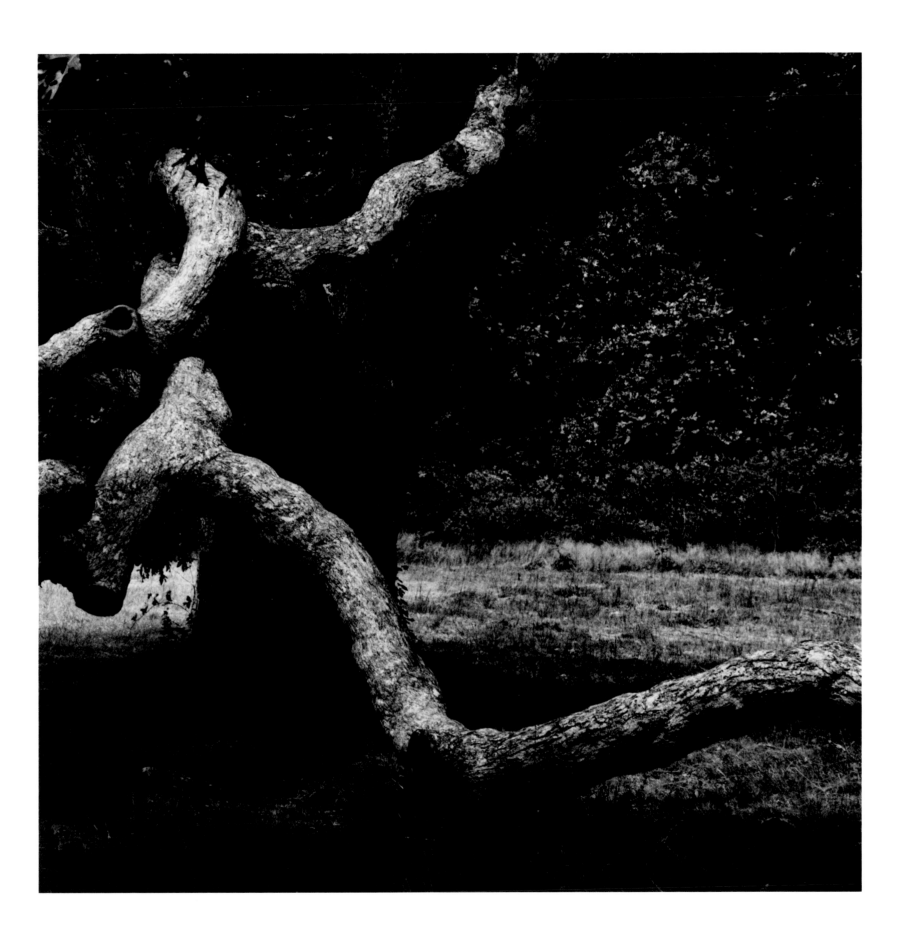

Martha's Vineyard (The Tree) 1972

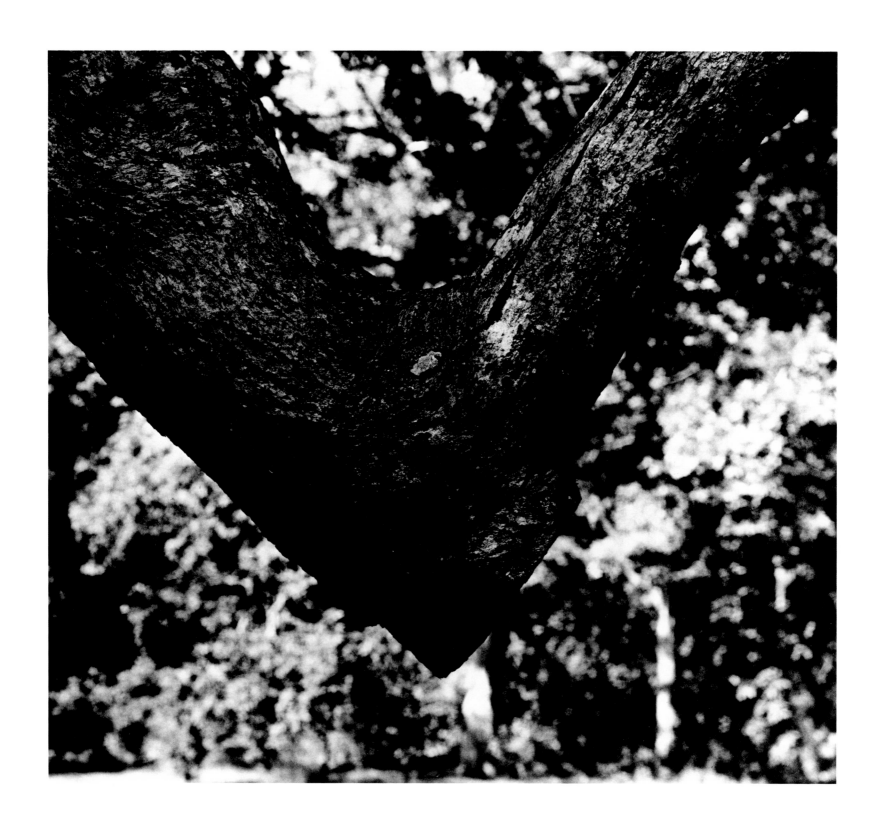

Martha's Vineyard (The Tree) 2 1972

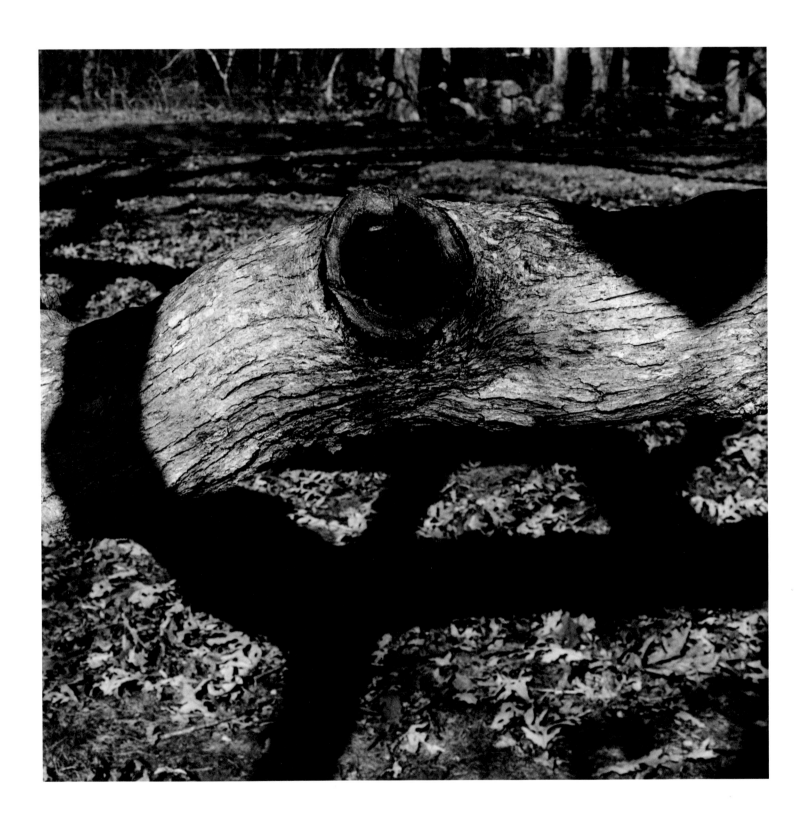

Martha's Vineyard (The Tree) 15 1971

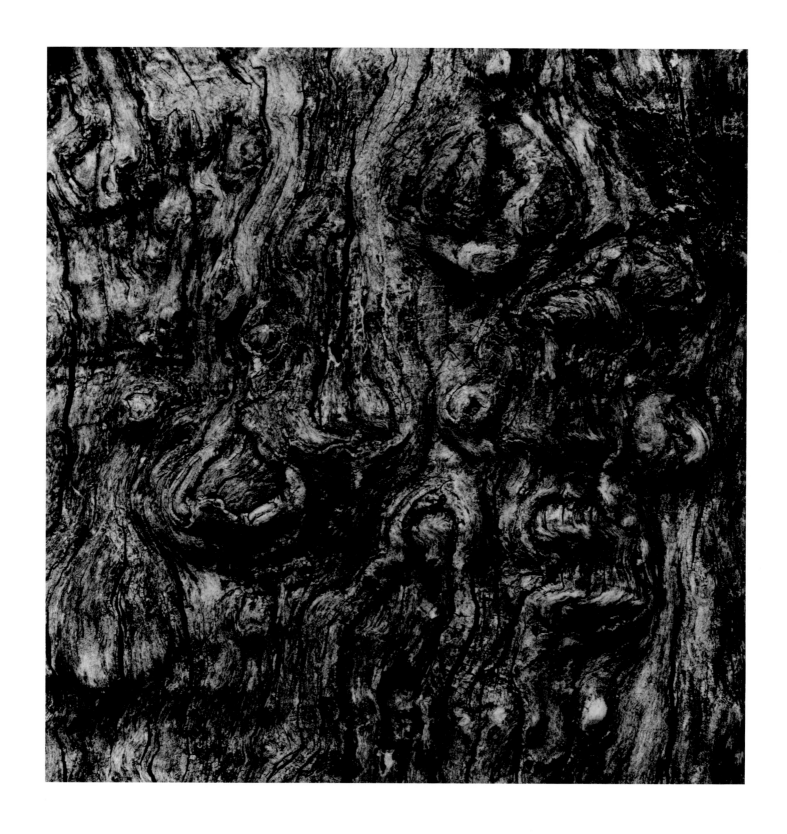

Millerton 2 1971

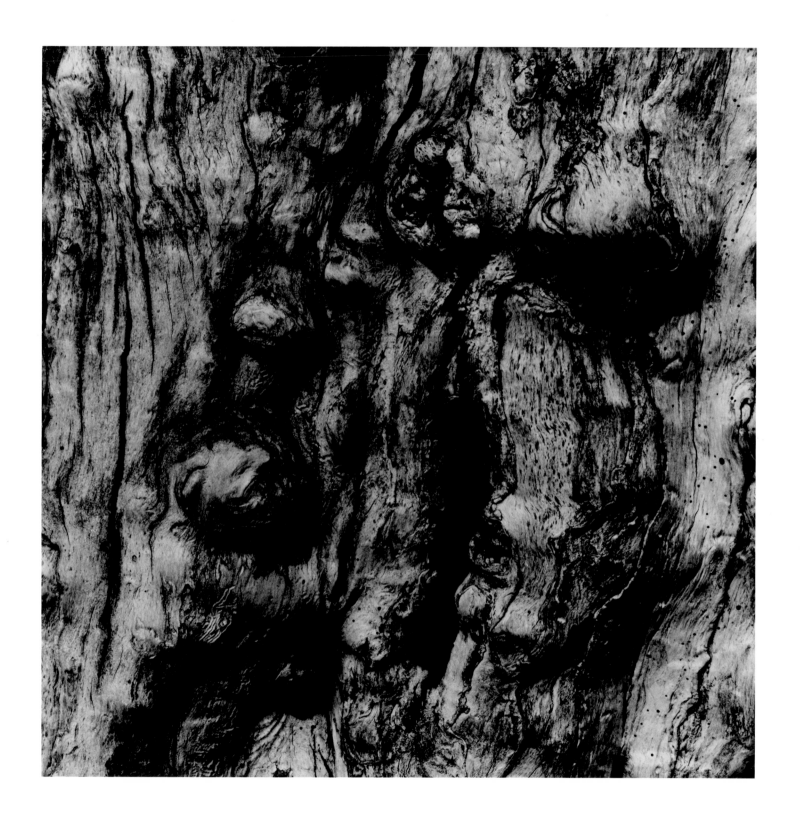

Martha's Vineyard (Old Horse) 1 1972

Martha's Vineyard (Old Horse) 46 1971

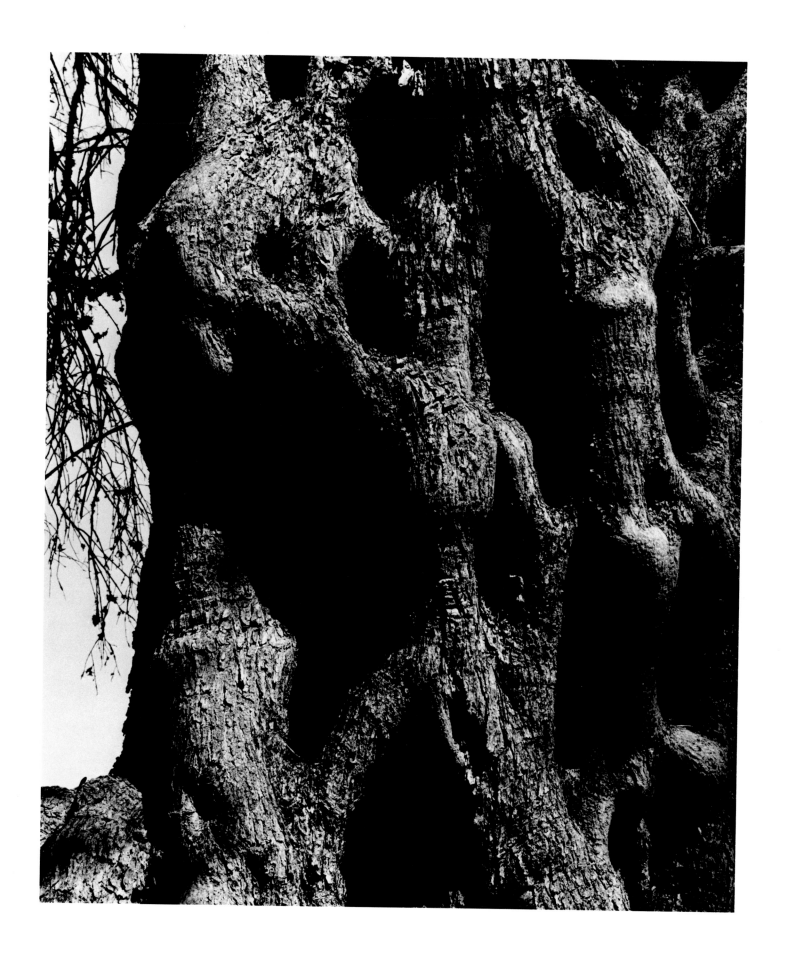

Corfu 19 1970

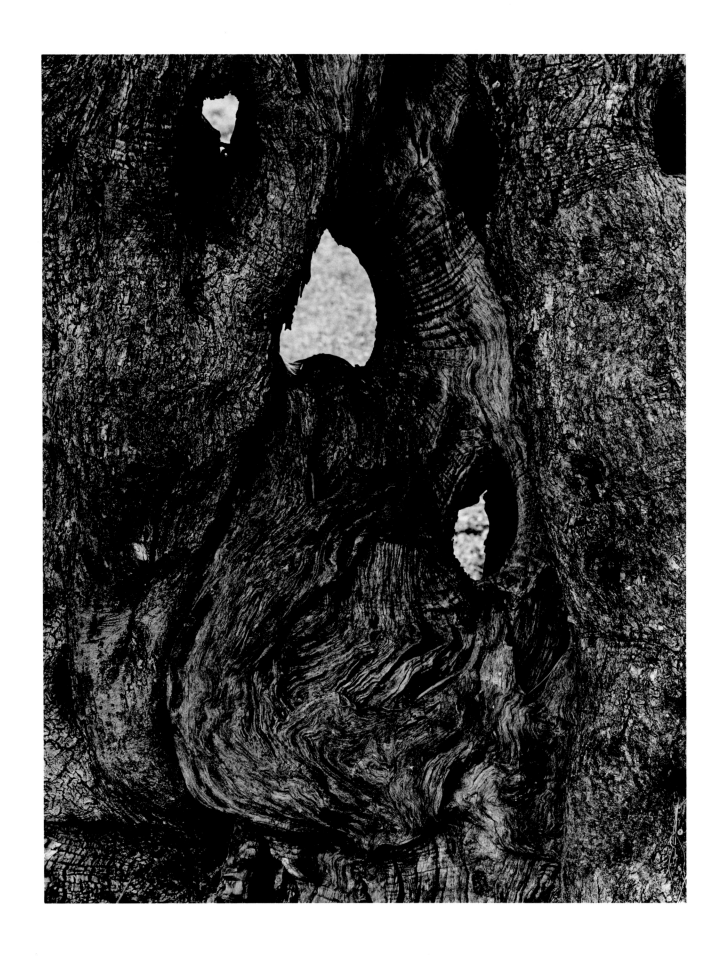

Corfu 500 1970

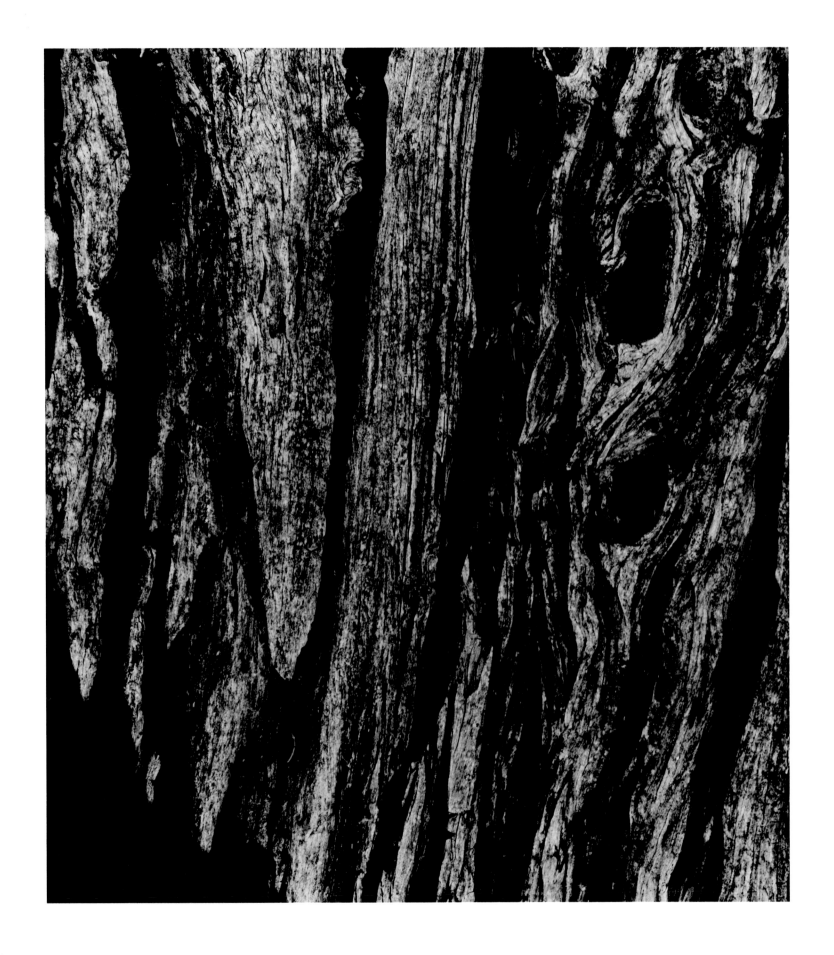

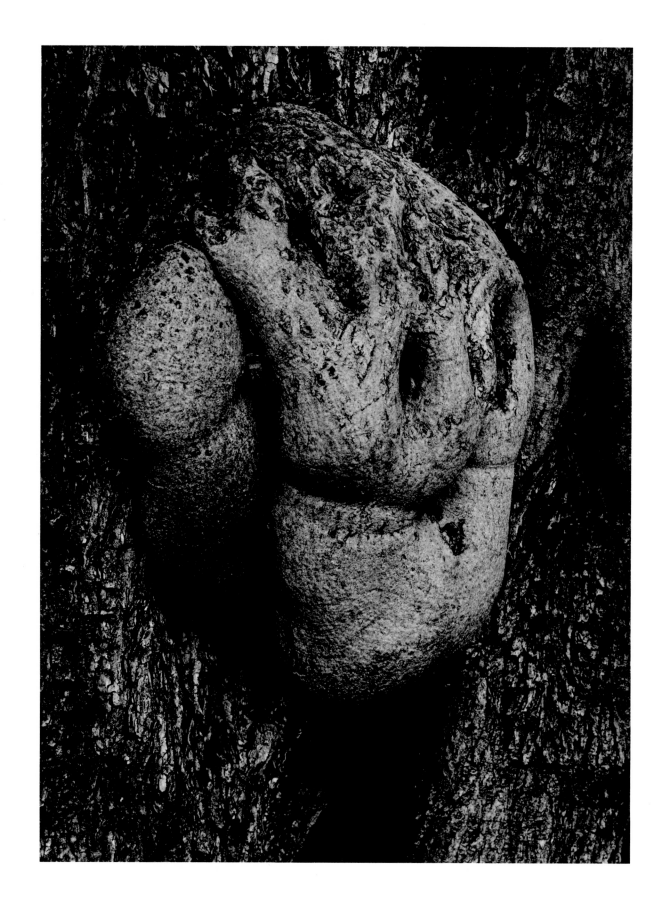

Corfu 514 1970

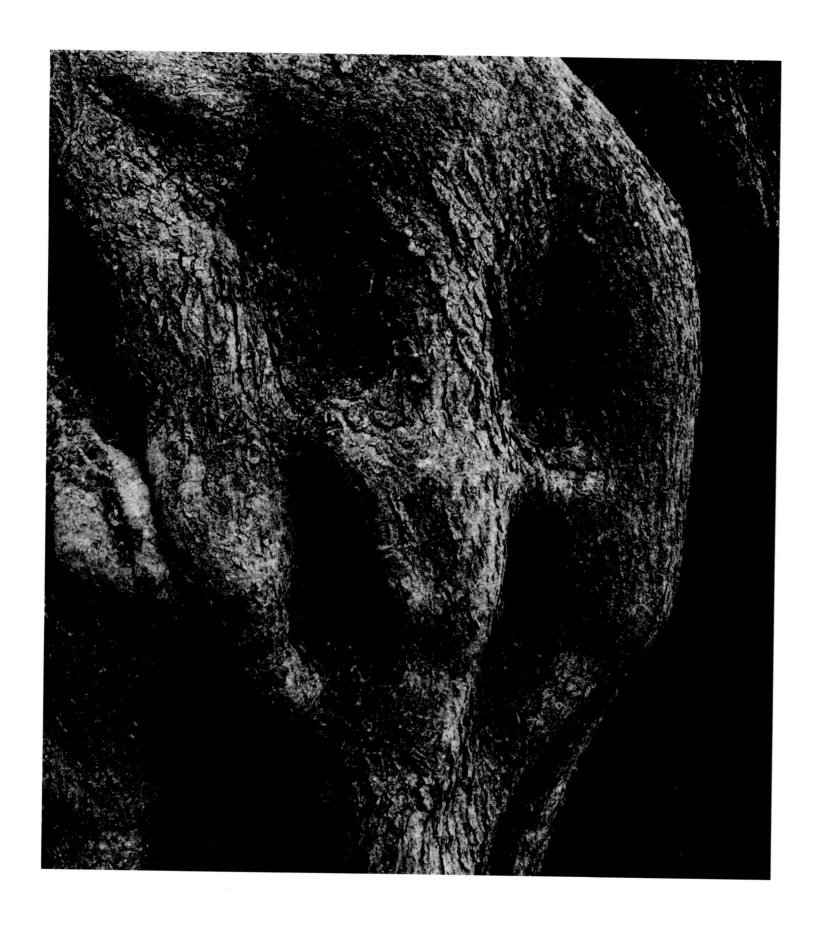

Corfu 127 1970

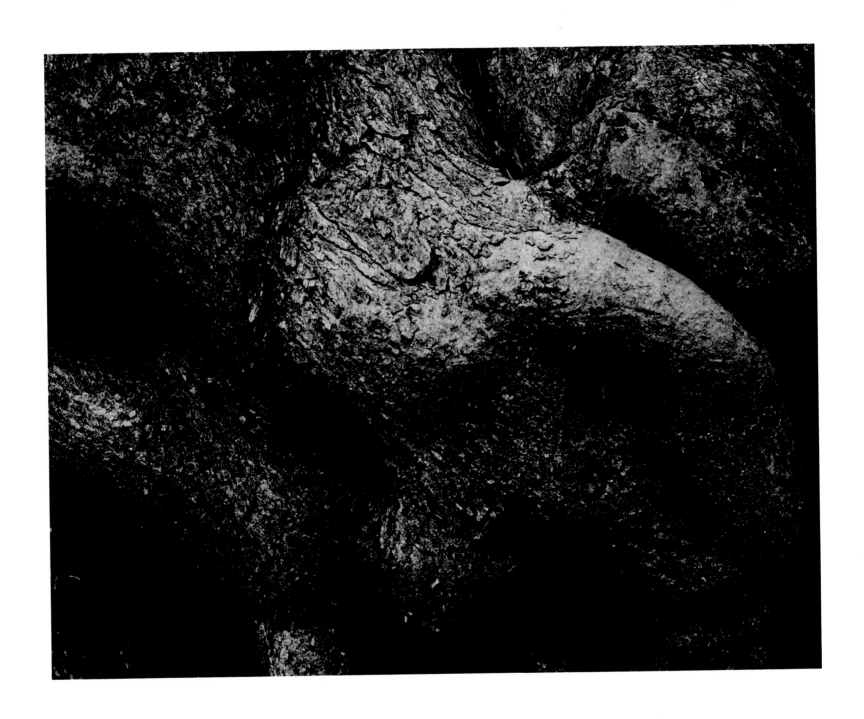

Corfu 532 1970

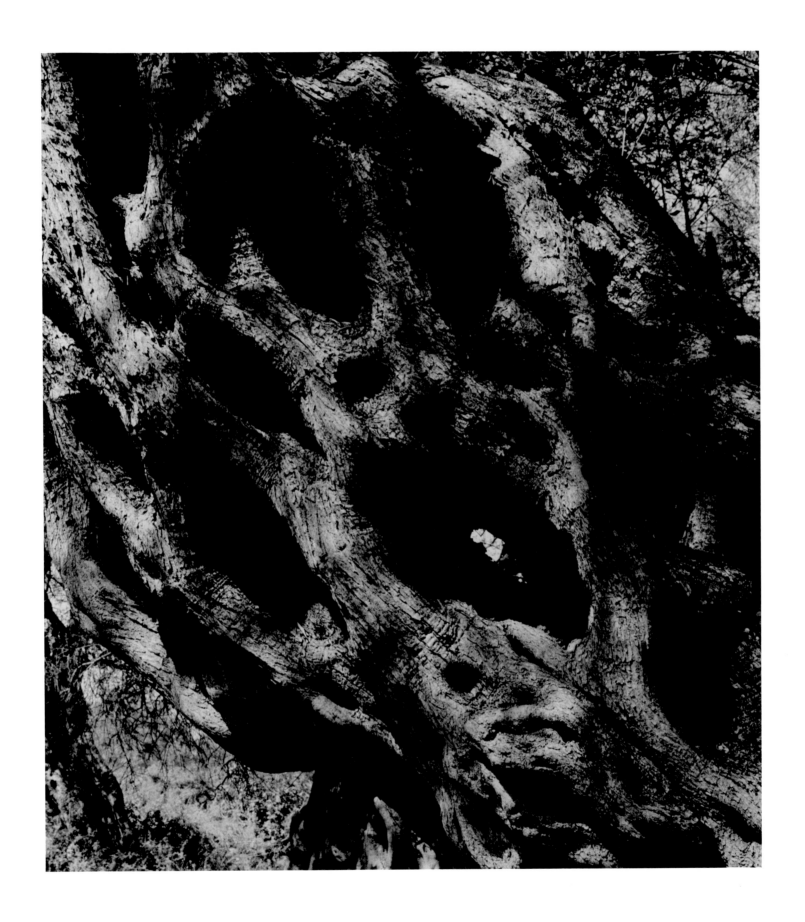

Corfu 17 1970

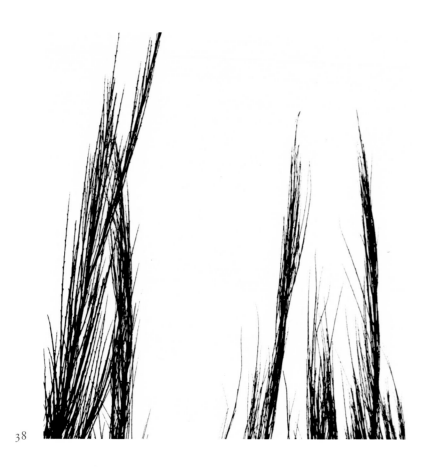

38

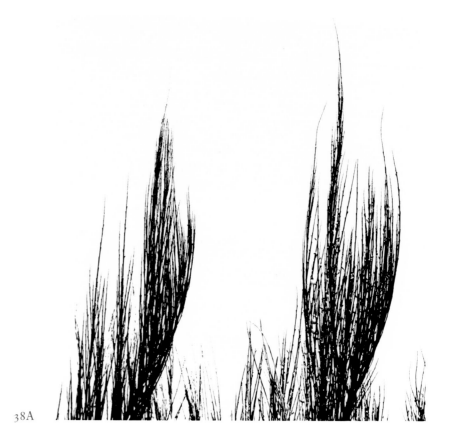

38A

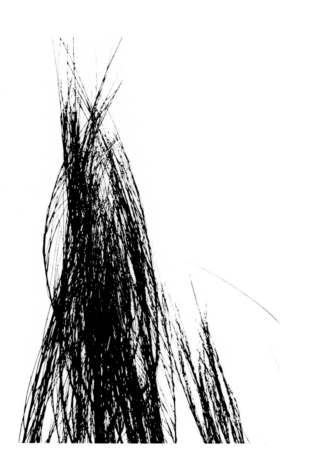

II

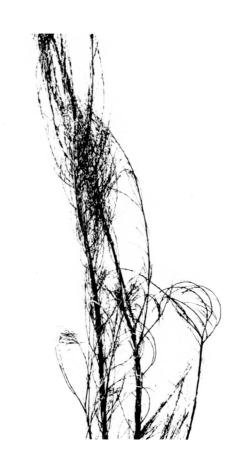

23

Viterbo 38 1970

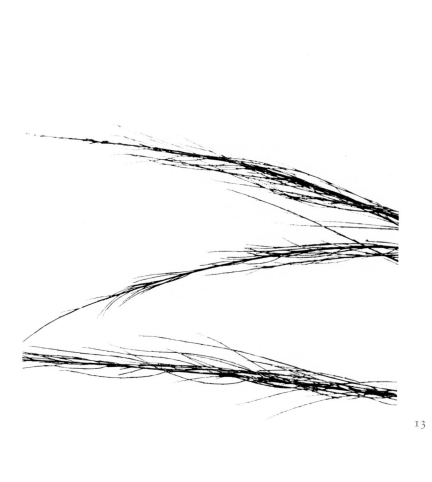

13

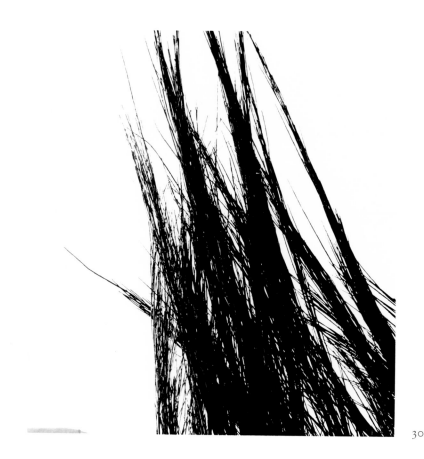

30

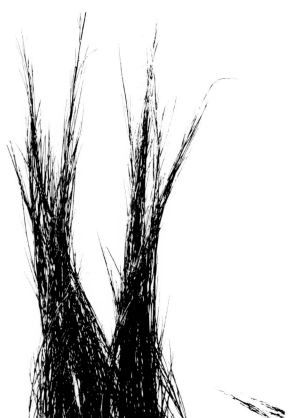

17

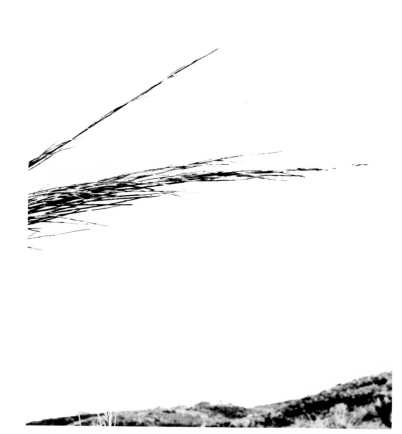

44

Index of Places

	page
Badlands (South Dakota)	31, 32, 33
Boston (Massachusetts)	20, 21, 35
Chilmark (Massachusetts)	77
Coatzacoalcos (Mexico)	13, 15, 16, 17
Corfu (Greece)	103, 104, 105, 106, 107, 108, 109
Cusco (Peru)	86, 87
Jalapa (Mexico)	54, 55, 56, 57, 58, 59, 60, 61, 62, 63, 64, 65, 90
Lima (Peru)	36, 37, 38, 39, 40, 41, 42, 43, 44, 45
Martha's Vineyard (Massachusetts)	75, 78, 93, 94, 95, 96, 97, 100, 101
Merida (Mexico)	18, 19
Millerton (New York)	98, 99
Providence (Rhode Island)	82, 83
Rome (Italy)	46, 47, 48, 49, 50, 51, 52, 53, 67, 68, 69, 79, 80, 81
South Dakota	23
Vera Cruz (Mexico)	24, 25, 26, 27, 28, 29, 70, 71, 72, 73
Villahermosa (Mexico)	89, 91
Viterbo (Italy)	110, 111
Woonsocket (Rhode Island)	84, 85